OSKAR KOKOSCHKA

MEMORIAL EXHIBITION

15 February – 17 March 2001

Marlborough

40 West 57th Street • NYC 10019 • 212.541.4900 • www.marlboroughgallery.com

Some of the works are for sale. Prices on application.

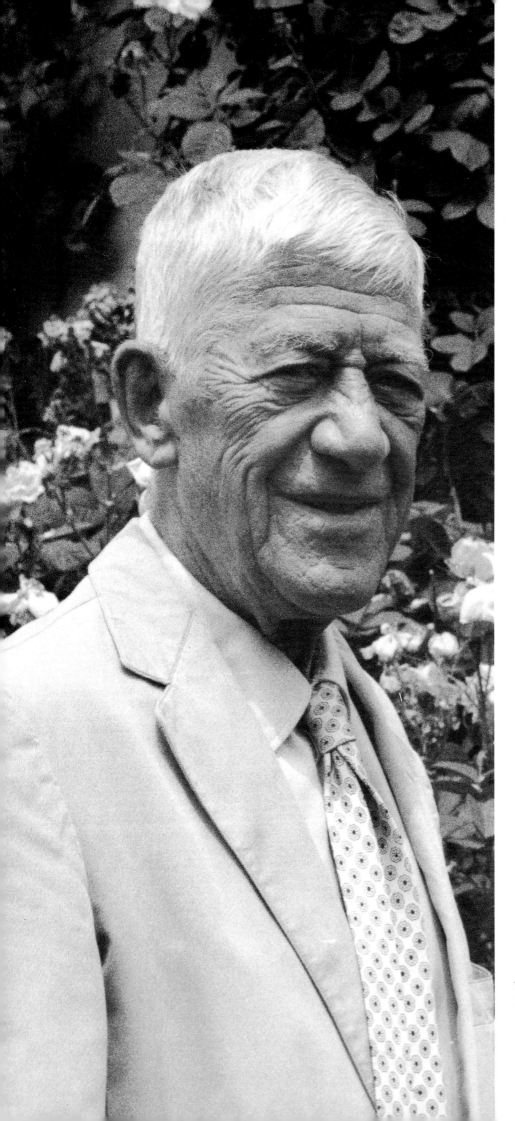

The artist in his rose garden, c.1972.
Photo by Gilbert Lloyd.

The Directors of Marlborough Gallery Inc. would like to thank Mrs. Olda Kokoschka, who has been most encouraging and informative from the outset, and without whom this exhibition would not have been possible. They are deeply appreciative of her invaluable efforts in preserving the legacy and work of her late husband.

They also would like to express their deepest gratitude for the generosity of all of those private collectors who lent and who wish to remain anonymous.

In addition, they are greatly indebted to Mr. Johann Winkler, of the Oskar Kokoschka Archive Vienna and co-author of the recently published new catalogue raisonné of paintings, for his exceptional scholarly contributions to this catalogue, as well as to all areas of research in the preparation of this exhibition. They would also like to thank Magister Alfred Weidinger, Vice-Director of the Sammlung Albertina, Vienna, for his help.

They are similarly thankful for the generosity of the museum directors from across the country, who have enabled Marlborough to include some of the finest Kokoschka works from throughout the artist's career in this exhibition: Ms. Celeste Adams of the Grand Rapids Art Museum; Mr. Jay Gates of the Phillips Collection, Washington DC; and Mr. Douglas Schultz of the Albright-Knox Art Gallery of Buffalo, New York.

Many others gave advice, information and help in the organization of this exhibition, who are too numerous to mention here and the Directors wish to thank them collectively. Notably, they acknowledge the assistance of the Detroit Institute of Arts for permission to reproduce their work, *Dresden, Neustadt II,* c.1921 in the catalogue, and in particular to Ms. Sylvia Inwood and Ms. Mary Ann Wilkinson (of that institution) for their invaluable efforts in this matter. They would also like to extend their appreciation to the considerations of the Minneapolis Institute of Arts, and its Director, Dr. Evan Maurer, as well as Mr. Marc F. Wilson, Director, and Ms. Deborah Emont Scott, Curator, of the Nelson-Atkins Museum of Art, Kansas City, Missouri.

Lastly, they would like to mention the excellent translations from German into English by Ms. Fiona Hulse, Newcastle-upon-Lyme, UK. Ms. Hulse met incredible deadlines and they are most thankful to her.

List of Lenders
Albright-Knox Art Gallery, Buffalo, New York
Grand Rapids Art Museum, Grand Rapids, MI
Phillips Collection, Washington, DC

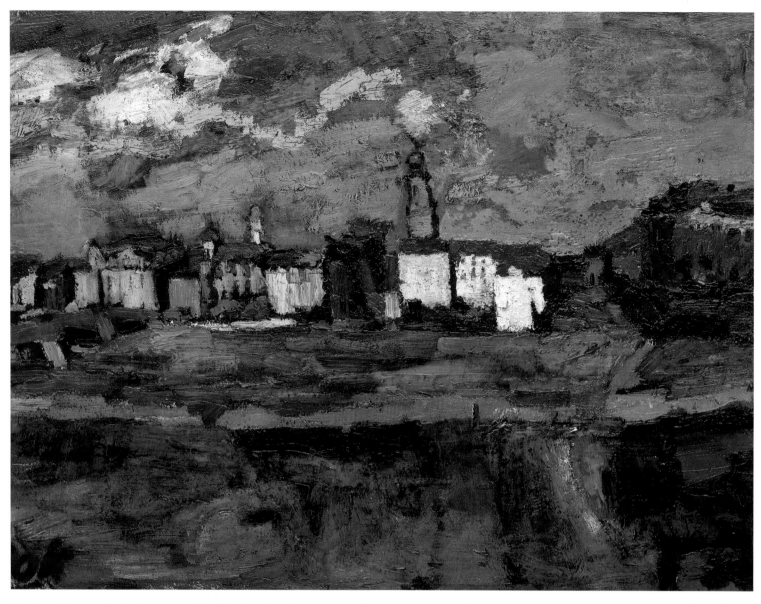

Dresden, Neustadt II, also known as *The Elbe Near Dresden,* c. 1921, oil on canvas. First Kokoschka work ever to be acquired by an American museum, acquired as a City of Detroit Purchase for the Detroit Institute of Arts in 1921. (Catalogue only. Photo courtesy Detroit Institute of Arts, ©1985 Detroit Institute of Arts.)

"…RANKING IN IMPORTANCE WITH PICASSO AND MATISSE."[1]
– The reception of the art of Oscar Kokoschka in the United States by Johann Winkler

The *Panama-Pacific International Exposition,* which was held to celebrate the opening of the Panama Canal, opened its doors in the Palace of Fine Arts in San Francisco in mid-August 1915. The 29-year-old Oskar Kokoschka, who at the time was still a very controversial figure in Vienna and was strongly attacked by the conservative critics, was with his fifteen paintings and one drawing the most important representative of new Austrian art at this large-scale international exhibition. He owed this distinction to the commitment of his friend and mentor Adolf Loos, who was willing to take risks on his behalf; despite the World War that had been raging in Europe since August 1914, he was approved at the highest levels in the United States government as a source of loan articles, and had fourteen paintings from his unique collection shipped to California.[2]

Loos was an architect, and at the 1908 Kunstschau in Vienna, which was Kokoschka's first public appearance, he immediately recognised the young artist's exceptional talent and from then onwards was unwavering in his efforts to help this talent gain general acceptance. Almost all of the portraits painted by Oskar Kokoschka between 1909 and 1914 had been produced by the direct or indirect mediation of Adolf Loos. However, very few of the people depicted on these portraits were prepared to buy or keep the pictures. Thus Loos, who had committed himself to keeping the portraits he had arranged if the people portrayed did not like them or were not able to afford them, was for many years the unwilling custodian of the largest collection of early masterworks by Oskar Kokoschka.[3] Without the loans of his property which he used to try and boost the fame of the young artist, none of the early exhibitions of oil paintings by Kokoschka would have been possible in a representative fashion. It is therefore all the more amazing that the exhibition of his works that took place within the framework of the Panama-Pacific International Exhibition was not mentioned in Kokoschka's memoirs and was also ignored for a long time in the relevant literature about Kokoschka.[4]

Loos himself had been in the United States from 1893 to 1896, mainly in New York. Despite great difficulties in gaining a foothold there, he would for the rest of his life remain an ardent admirer of the openness and impartiality of the American way of life. He doubtlessly hoped that his Kokoschka loans to San Francisco would draw the attention of the American art-loving public to his protégé: a hope that was to remain unfulfilled.

It is possible that the pictures traveled on to New York after the exhibition in San Francisco finished, in order to be exhibited in Greenwich Village in October 1915. Afterwards they certainly had to return to San Francisco as the British government would no longer guarantee the originally promised safe-conduct for their transport home. They were even confiscated[5] in April 1919 as enemy property and retained until late spring 1924. Not until July 1924 did their odyssey end with the safe return of all the paintings to Vienna.

In Germany after the war, Oskar Kokoschka had secured his position as one of the leading artistic figures of his generation. A contract signed in October 1916 with the renowned Berlin art dealer Paul Cassirer provided financial security, and his appointment as professor at the Dresden Academy in August 1918 provided a high degree of recognition and considerable independence. The time was not yet ripe for him to make a breakthrough and achieve a similar level of importance in the United States. It is true that contemporary German art had met with ample interest within the framework of the Armory Show in New York in 1913.[6] However, the outbreak of war caused the links to be severed. The already dominant admiration for current artistic work in France greatly restricted their involvement in the artistic developments in other countries.

One figure who, immediately after the break caused by the War, once again made himself an advocate for German art in America was the art historian Wilhelm R. Valentiner, who was born in Germany and had trained in Berlin under Wilhelm von Bode at the Kaiser Friedrich Museum. Valentiner had already worked at the Detroit Institute of Arts from 1908 to 1914, had returned to Germany in 1914 before moving back to Detroit in 1921, and from 1924 to 1947 he was the head of the Institute of Arts. He succeeded in achieving what Adolf Loos' initiative in the American West had tried to achieve in vain: the first purchase of a Kokoschka painting for an American museum. The urban landscape *Dresden, Neustadt II*, created in the spring of 1921, was bought in the late summer of the same year by the city of Detroit for the Detroit Institute of Arts, "a quiet flowing picture framed at the top by a jagged sky".[8]

In the autumn of 1923 Kokoschka left his chair in Dresden and travelled to Switzerland. The death of his father in October 1923 brought him back to Vienna and his family. During 1924 he stayed in Venice, Florence and Paris. Thanks to the generous terms of the contract with Paul Cassirer, 1925 was the start of five tireless years of travelling filled with an immense creative urge. In-between Scotland, London, Holland, the French Alps, southern France, Spain, North Africa, Jerusalem and Istanbul, to name just a few destinations, a unique gallery of urban and landscape pictures was created–and always within the "borders of the classical Roman Empire". "I do not travel with the romantic intention of shedding tears over the past," we read in the final chapter of his autobiography <u>My Life</u> beneath the heading "The spiritual light". "What is past is past. ... [I] do my best not to forget my spiritual forebears. ... For me European culture has not lost its meaning."[9]

Major retrospectives in Mannheim and Paris in 1931 assessed the works that had been created by then and the fruits of his years of travelling. In the exhibition *German Painting and Sculpture* in the Museum of Modern Art in New York in spring 1931, just one and a half years after the museum was founded, Kokoschka–once again thanks to the support of Wilhelm R. Valentiner–was represented by four paintings.

Despite these successes, the personal and financial circumstances of the artist, who at this point was living mainly in Paris, steadily worsened. The difficulties in selling works of art created by the worldwide economic crisis led to his contract with the Galerie Cassirer being cancelled. On the political front, the attacks on the part of the National Socialists that started in 1930 were the first dark signs of the imminent catastrophe which, in Germany under Adolf Hitler, would soon lead to the extinction of independent intellectual life, to the branding of contemporary modern art as "degenerate", and finally to the beginning of a new global conflagration.

In the shadow of this threatening development, Austria gave the artist who was seeking security very little chance of success. Influenced by the Civil War of February 1934 and deeply affected by the death of his beloved mother on 4 July 1934, Kokoschka turned his back on his native city of Vienna. A ten day trip to Prague planned for the end of September 1934 turned into a four year long stay in Czechoslovakia. During these years, a total of sixteen views of the "golden" city of Prague were created, and amongst several portraits the exceptional one, by virtue of his combination of political allegory and striking portraiture, is that of the Czechoslovakian president T. G. Masaryk.[10] Prague provided Kokoschka with the freedom to express his humanitarian commitment and political concerns in warning essays and newspaper articles. In the house of the lawyer K. B. Palkovsky in Prague, he became acquainted with Olda Palkovská, just twenty at the time, who was later to be his wife and would be his companion for 45 years until his death, and beyond his death the first guardian of his legacy.

In the face of the constantly growing threat spreading from the dictatorship in Germany, however, the artist was increasingly minded to leave Europe, and his mind turned repeatedly to his connections in America. On 25 March 1936, for example, he wrote to Wilhelm R. Valentiner: "I was stupid not to have come to the States with you, for by now I would have been world-famous over there, whereas here in Europe the houses of cards collapse as soon as you build them…Could one paint the President of the United States?"[11] And on 16 September 1936 to the German-born art historian Alfred Neumeyer, at the time working in San Francisco as the principal of the summer school of Mill's College: "…it would give me great pleasure to teach at the Summer School next summer, and to use this opportunity to finally paint San Francisco, something I have long had in mind."[12]

Kokoschka was no longer an unknown in the art world of the United States. As early as 1924 Sheldon W. Cheney had made an emphatic reference to his position by postulating that: "Oskar Kokoschka is the most significant figure in mid-European art today, ranking in importance with Picasso and Matisse."[1] From 1925 he was regularly represented in the annual exhibitions held in Pittsburgh by the Carnegie Institute, and in 1937, with the painting Prague, Karlsbrücke[13], he was even one of the seven award winners of the year.

When Kokoschka finally left Prague together with Olda in October 1938, however, he did not go to either Detroit, New York, Pittsburgh or San Francisco: he went to London. In Germany, from 1937 onwards, Kokoschka's works in museums and private collections fell prey to confiscation. The artist was also represented by eight large paintings at the touring exhibition Entartete Kunst (Degenerate Art), and the increasing contempt with which his work was treated and pilloried in Germany was only matched by the increasing interest in his work in the United States, and the high regard in which it was held by public collections and private collectors. A major role in this "reversal of values" was played by emigrant art dealers such as Curt Valentin, who ran the Buchholz Gallery in New York, and Otto Kallir, who under the name of Otto Nierenstein had already represented Oskar Kokoschka in his Neue Galerie in Vienna and now, in his Galerie St. Etienne in New York, continued to lend him his support.[14]

In 1945, Alfred Neumeyer published his essay, "Oskar Kokoschka", which was the first significant appreciation of the artist on an international level after the end of the Second World War.[15] In 1961 he produced the following memorable summing up: "Kokoschka's development, like Munch's, runs counter to the current of the century. He starts as an Expressionist but, toward the end of the 1920s turned to a naturalistic-impressionistic style. The two phases are combined by the unique personality of the artist; they constitute, moreover, a meaningful psychological development from self-dramatising subjectivity to a more objectively observant attitude. Inspiration and improvisation give his work the air of something still unfinished, suggesting a process rather than an end product…With Kokoschka, we participate in a genesis of insight and its translation into form."[16]

The major breakthrough came in 1948 and 1949 with the retrospective organised by James Plaut; consisting of 62 paintings and a selection from Oskar Kokoschka's graphic works, the exhibition started in Boston and traveled right across the United States, from Washington to St. Louis and San Francisco, then via Wilmington back to the East Coast and New York, where the exhibition reached a brilliant conclusion in the Museum of Modern Art.[17] Together with the retrospectives exhibited in Europe in 1947 and 1948, in Basel, Zurich, Amsterdam and Venice, the American touring exhibition, which was the first outside Europe to display a representative cross-section of his entire work, finally established the international standing of the artist, who at that time was 62 years old. Basel greeted him as a "painter of the history of our age", Venice as a "pittore solitario", and "dramatist in paint". A review of the MOMA exhibition was headed "A fine painter whom Hitler called 'degenerate'," and the New York Times characterised Kokoschka's art as "expressionism in a gentle vein". The presentation in the Phillips Gallery in Washington in January 1949 was the first time that Kokoschka, together with his wife Olda, had person-

ally come to the United States. In the exhibition, he stood looking at his pictures of his life in the focal point of Europe's turbulent history, and was heard to remark that America would soon take over the leading role in artistic life.

The success of the exhibition was not exactly unfruitful. As early as July 1949 the artist held a summer course at the Tanglewood Summer School close to Boston. In September he travelled further to Minneapolis in order to work on his first commissioned portrait there. The portrait of husband and wife John and Bettie Cowles was the first painting produced in the States.[18] In November and December 1952 Kokoschka returned to Minnesota as a guest lecturer at the Minneapolis School of Art. This is the period when the portrait of Pete Gale[19], the politician's wife and the journalist Alfred P. Gale was created. Finally, in the winter of 1957/1958, there was a further stay in Minneapolis during which two portraits were commissioned and he held a course for advanced students. Oskar Kokoschka painted a portrait of the realtor Putnam Dana McMillan, who was about to retire as president of the Board of Trustees of the Minneapolis Society of Fine Arts[20], and finally one of Alfred P. Gale, who was also a member of the Board of Trustees of the Minneapolis Institute of Arts.[21]

America never became a real home to the artist who was deeply rooted in the intellectual traditions of Europe. In 1953, he moved into his first own house in Villeneuve on the shores of Lake Geneva, complete with the studio that was always called the "library"; from there he regularly set off on extended journeys and to the annual summer courses held between 1953 and 1963 at the *Internationale Sommerakademie für Bildende Kunst* in Salzburg, of which he was a founding member. New portraits and new views of cities and landscapes were created, together with large history paintings and a many-sided late graphical work.

In New York, in addition to the Galerie St. Etienne, it was Serge Sabarsky and above all Marlborough Fine Art who were responsible, from the end of the Fifties, for caring for Oskar Kokoschka's work, and they did this by regularly displaying older works that had already been admitted to the canon of classical modern art opposite newly created pictures. In 1966 and 1976, Marlborough presented major retrospectives on the artist's 80th and 90th birthdays, and following his death in February 1980 they devoted the first major commemorative exhibition to him, which took place in summer 1981.

When he was eighty years old, Oskar Kokoschka once more made the voyage by ship across the Atlantic on the occasion of the birthday exhibition in the Marlborough-Gerson Gallery. The idea of using the sphere of the visit to paint a view of Manhattan was followed by several days searching for suitable vantage points; finally, the correct location that was acceptable to the artist was found in an office on the 33rd floor of a skyscraper on 40th Street. The painting *New York, Manhattan with the Empire State Building*[22] was one of his most magnificent urban landscapes; a picture which combined the generosity of the old master with the radicality of the "young wild thing" in the apotheosis of the metropolis which never rests. In Kokoschka's vision, the pulse of the city beats at the rate of an ocean liner heading for the open seas. The innermost essence of such movement may have remained foreign to the artist; but he felt its pulse like no other.

—Vienna, December 2000.
Translated from German by Fiona Hulse, Newcastle-under-Lyme, UK

Footnotes:
1. Sheldon Warren Cheney. A primer of modern art. New York 1924. Quoted here from the New York 1945 edition, p. 201.
2. Works owned by Adolf Loos that were exhibited: *Adolf Loos* (W/E 28), *Peter Altenberg* (W/E 31), *Self-Portrait with Brush* (W/E 112), *Emma Veronika Sanders* (W/E 47), *Anton von Webern* (W/E 111), *Cat* (W/E 55), *Paul Scheerbart* (W/E 52), *Conte Verona* (W/E 41), *Ludwig, Ritter von Janikowski* (W/E 27), *Martha Hirsch* (W/E 23), *Bessie Bruce* (W/E 38), *Playing Children* (W/E 24), *Elisabeth Reitler* (W/E 32), and *Child with its Parents' Hands* (W/E 25). One painting, the portrait of the composer Egon Wellesz (W/E 65), was not lent by Adolf Loos but by Wellesz personally. W/E = Johann Winkler/Katharina Erling. Oskar Kokoschka: Die Gemälde, 1906-1929, Salzburg 1995.
3. cf. the chapter "Wie der Geisterkönig in einem Raimund-Märchen" in: Werner J. Schweiger. Der junge Kokoschka. Leben und Werk 1904-1914. Vienna, Munich 1983, p. [116]-123.
4. cf. Burkhard Rukschcio/Roland Schachel. Adolf Loos. Leben und Werk. Salzburg & Vienna 1982, p. 200-201.
5. ibid., p. 235-236.
6. The *International Exhibition of Modern Art,* based on the *Internationale Kunstausstellung des Sonderbundes Westdeutscher Kunstfreunde und Künstler zu Cöln 1912,* which was held by the Association of American Painters and Sculptors and included works by Hodler, Lehmbruck, Marc and Kandinsky.
7. W/E 145
8. Margaret Heiden. "Neue deutsche Kunst im Detroit Institute of Arts." In: Museum der Gegenwart, Berlin, vol. 2, H. 1 (2nd quarter of 1931), p. 13-22, quotation p. 18, ill. p. 15.
9. Oskar Kokoschka: Mein Leben. Munich 1971, p. 304.
10. Since 1956 in the Museum of Art, Carnegie Institute, Pittsburgh. Hans M. Wingler. Oskar Kokoschka: Das Werk des Malers. Salzburg 1956, no. 298, plate 97.
11. Quoted from the chronology by Katharina Schulz (Erling) in the catalogue for the Oskar Kokoschka, 1886-1980 exhibition, London, Tate Gallery, 11 June-10 August 1986, p. 352.
12. Oskar Kokoschka: Briefe III, 1934-1953. Eds. Olda Kokoschka and Heinz Spielmann. Düsseldorf.
13. Wingler (see note 9), no. 289, colour plate XX.
14. The Buchholz Gallery, for example, presented exhibitions of Kokoschka's works from 22/9-12/10/1938 and from 27/10-15/11/1941 with first 5, then 20 paintings, plus graphic works; the Galerie St. Etienne, which had still been presenting paintings and drawings by Kokoschka in Paris in the spring of 1939, exhibited 15 paintings and 11 drawings in New York from 9/1-2/2/1940.
15. *Magazine of Art,* Washington, D.C., vol. 38, no. 7 (November 19445), p. 261-265 and 279.
16. Neumeyer, Alfred. Die Kunst in unserer Zeit. Stuttgart 1961. Here quoted from the English edition "The search for meaning in modern art", Englewood Cliffs, N.J., 1964, p. 77.
17. *Oskar Kokoschka. A retrospective exhibition.* With an introduction by James S. Plaut and a letter from the artist. New York 1948.
18. Wingler (see note 9), no. 361, plate 113.
19. Wingler (see note 9), no. 378 with ill.
20. Not in Wingler. To be included in the forthcoming revised complete catalogue of the oil paintings of Oskar Kokoschka (Volume II) by Johann Winkler and Katharina Erling, no. 424.
21. As note 20, no. 425.
22. As note 20, no. 465.

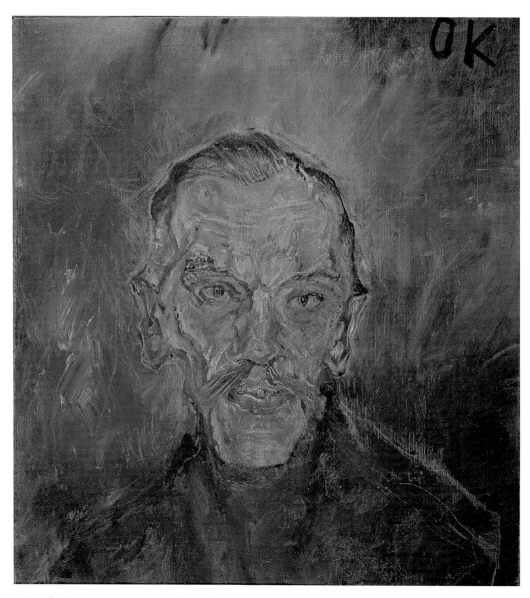

1 **Ludwig, Ritter von Janikowski** 1909

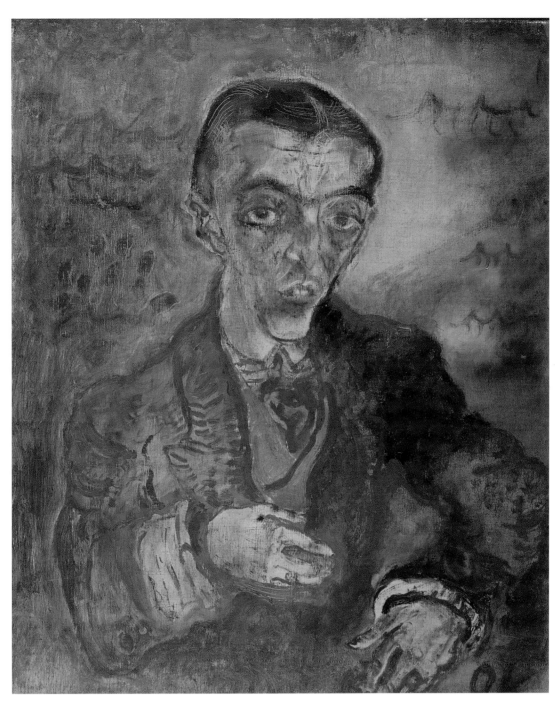

2 **Conte Verona** 1910

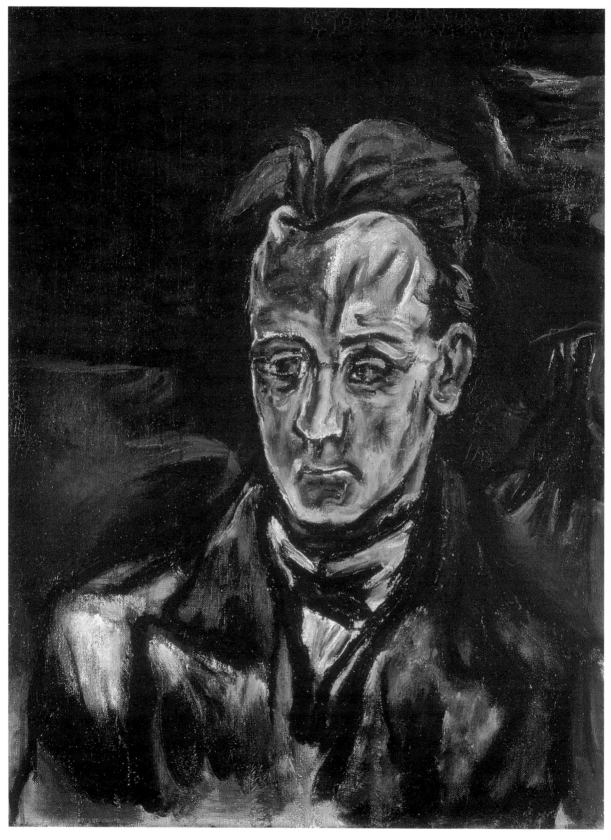

3 **Anton von Webern** 1914

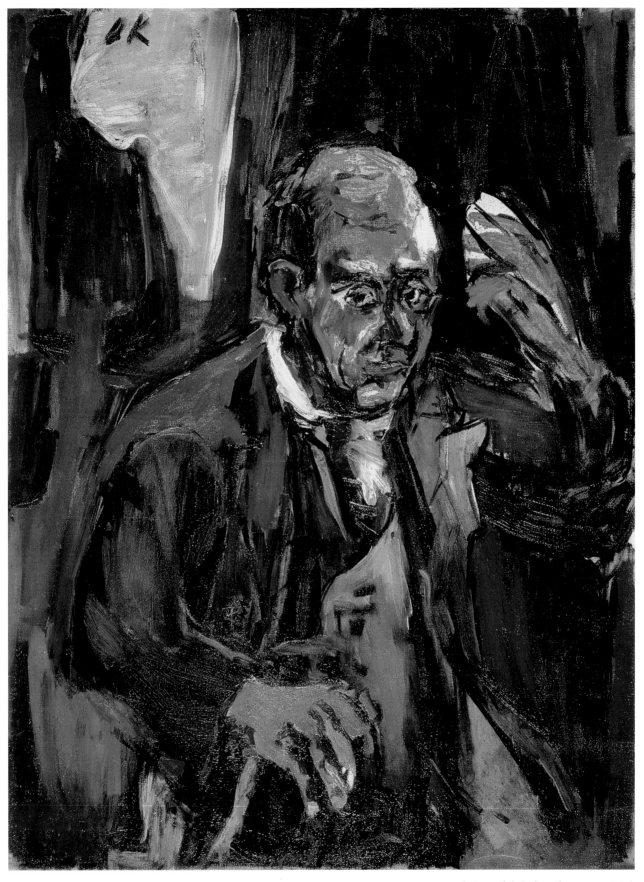

4 **Arnold Schönberg** 1924

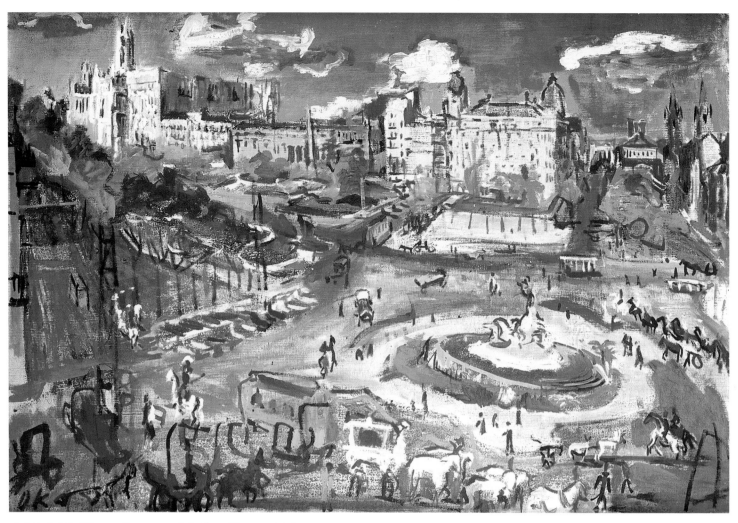

5 **Madrid, Plaza Canovas del Castillo** 1925

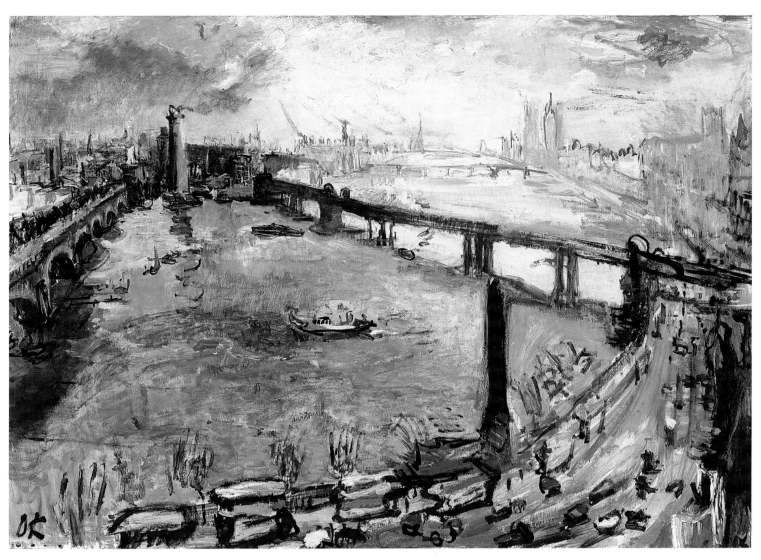

6 **London, Large Thames View I** 1926

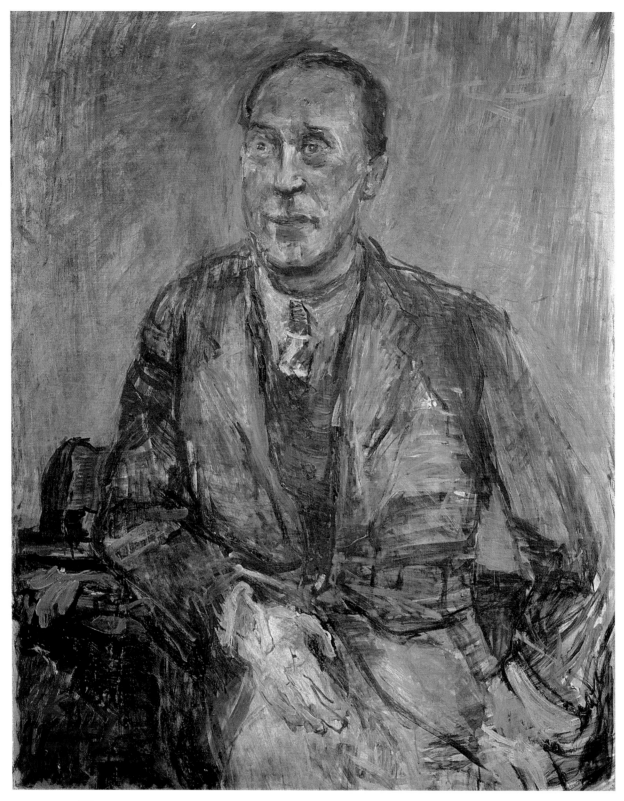

7 **Fritz Wolff** 1927

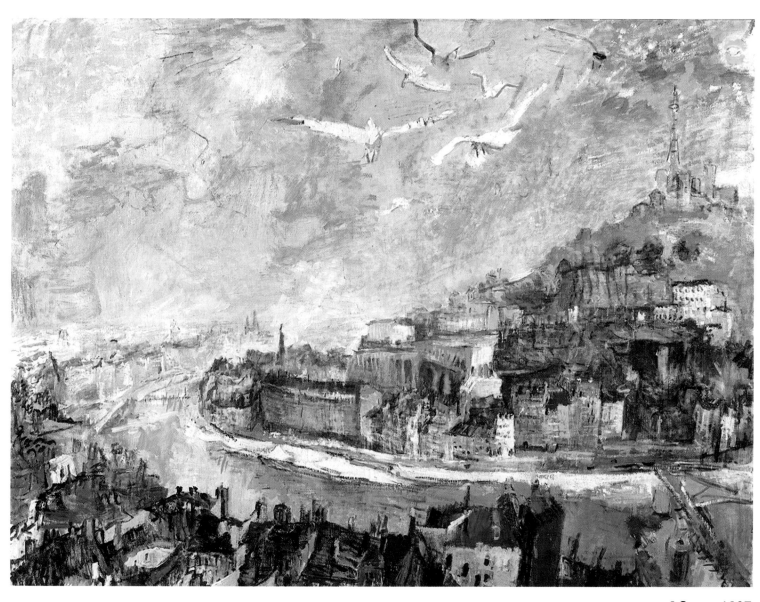

8 **Lyon** 1927

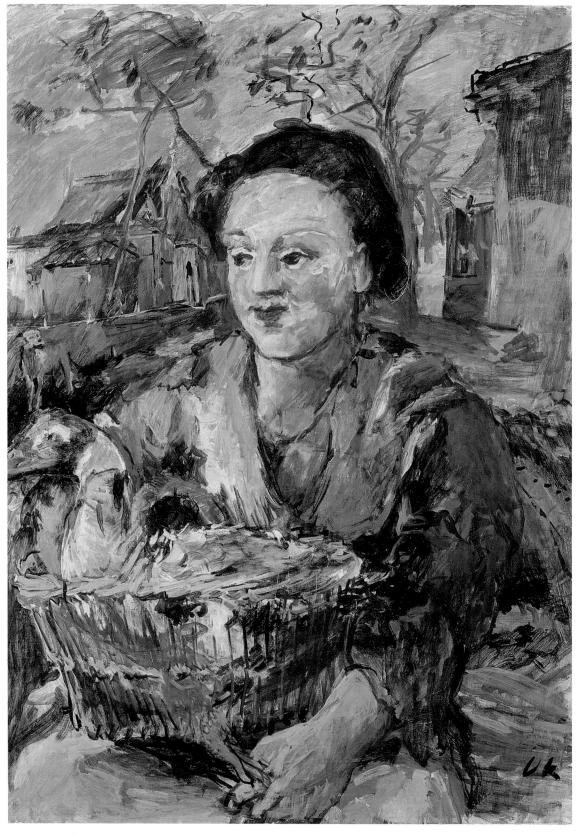

9 **Girl with Goose in Basket** 1930

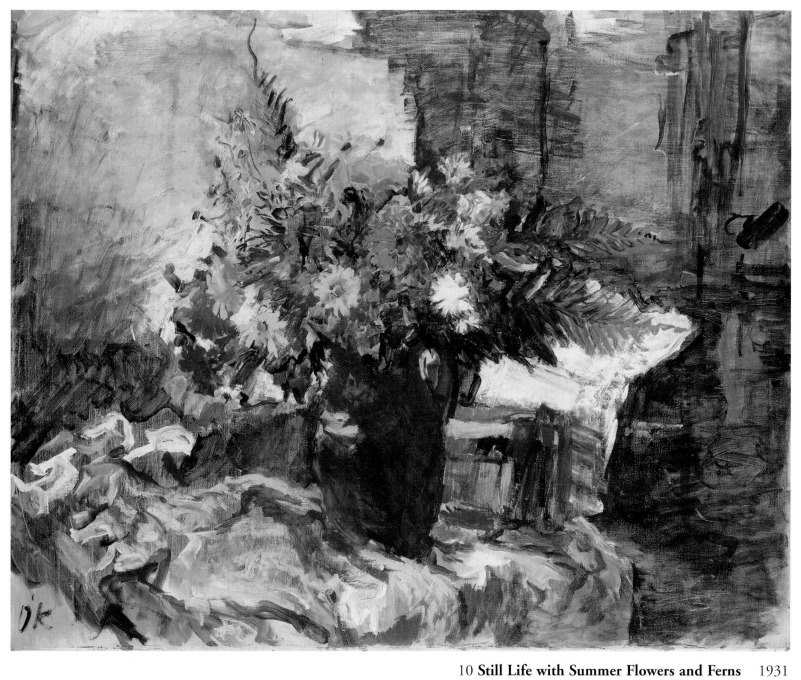

10 **Still Life with Summer Flowers and Ferns** 1931

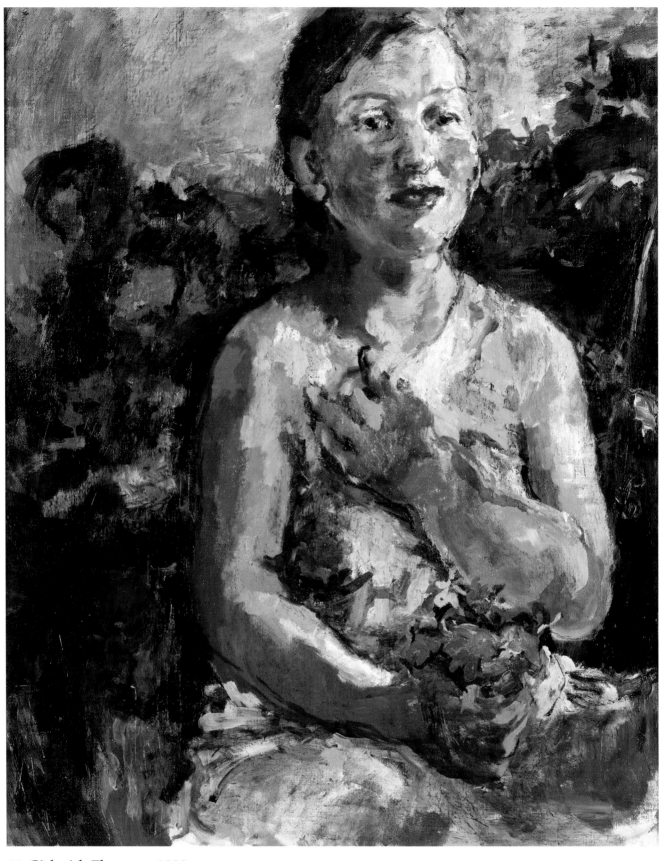

11 **Girl with Flowers** 1932

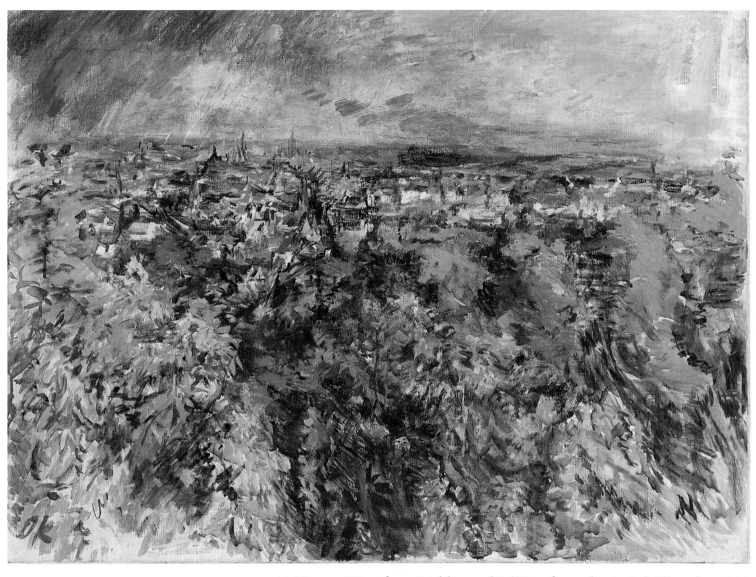

12 **Vienna, View from Liebhartstal I (View from the Artist's House)** 1933

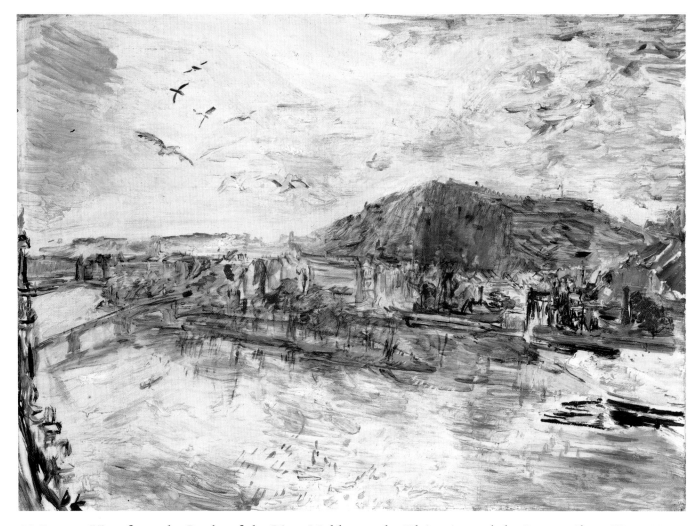

13 **Prague, View from the Banks of the River Moldau to the Kleinseite and the Laurenziberg II** 1937

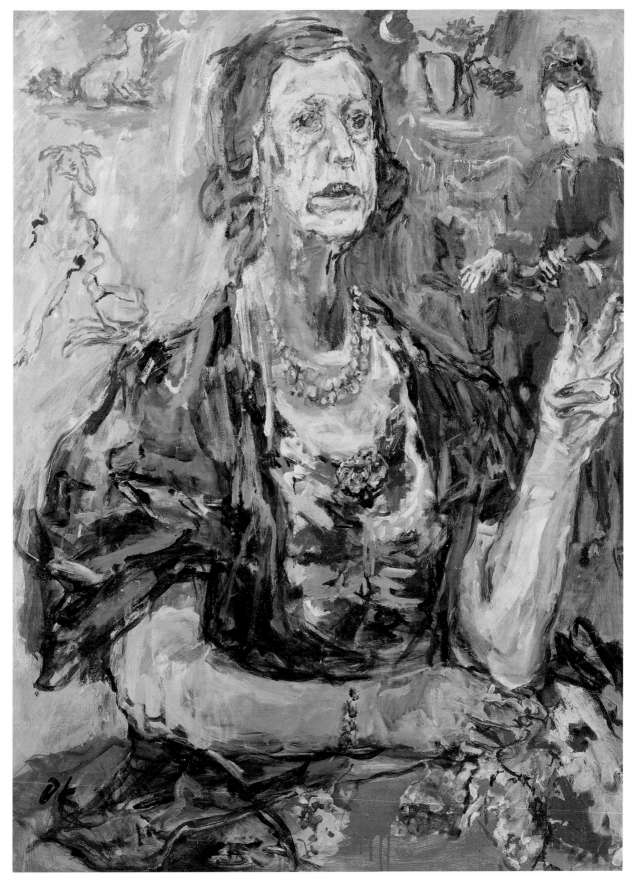

14 **Kathleen, Countess of Drogheda** 1944-47

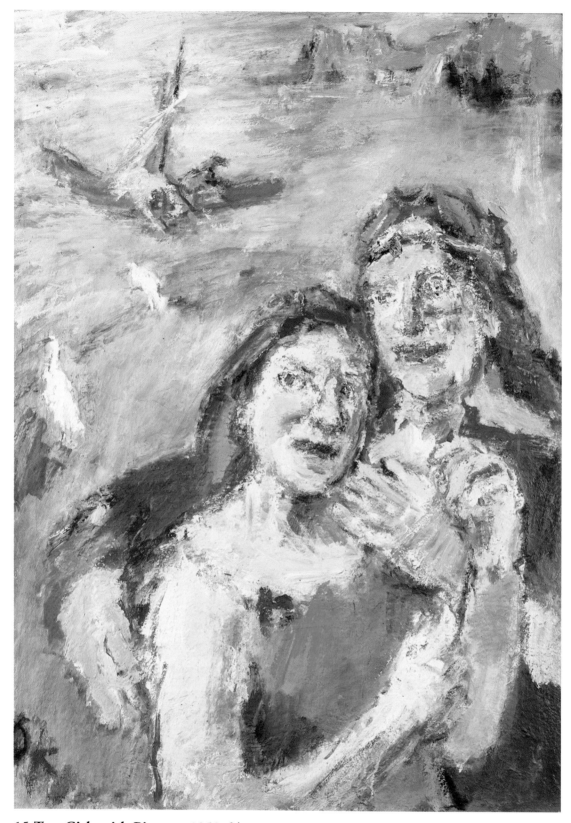

15 **Two Girls with Pigeon** 1953-64

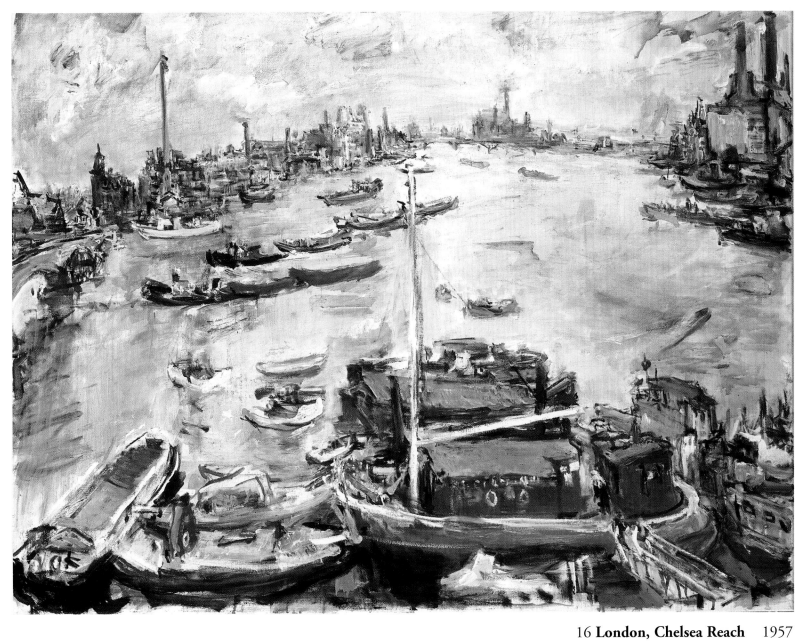

16 **London, Chelsea Reach** 1957

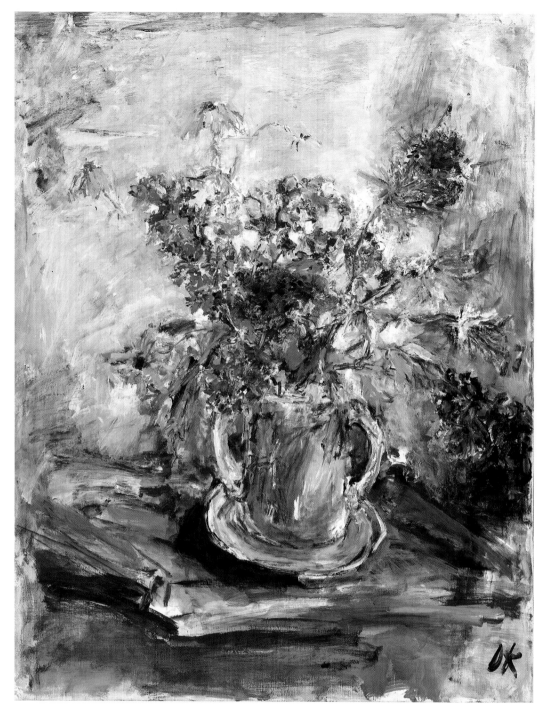

17 **Still Life with Flowers** 1959

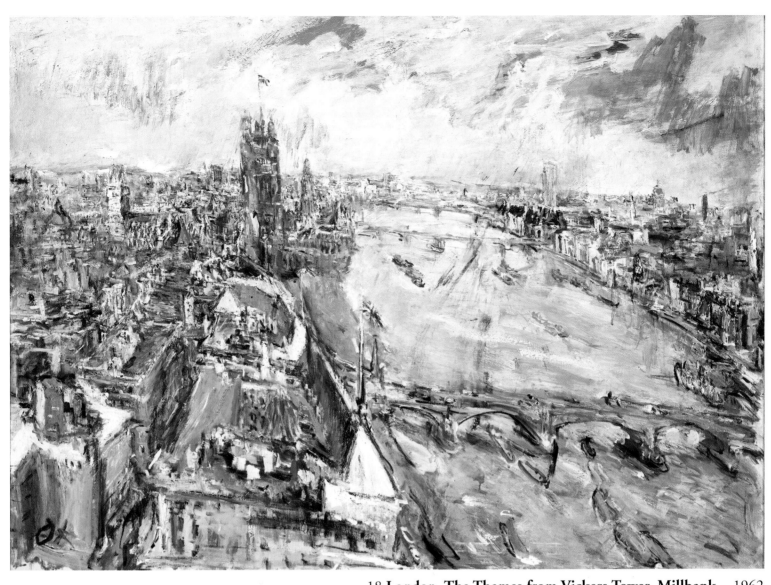

18 **London, The Thames from Vickers Tower, Millbank** 1962

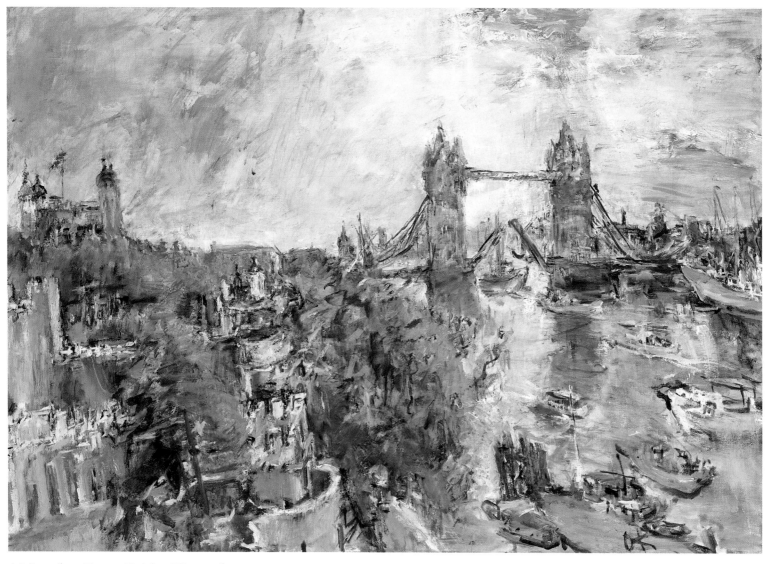

19 **London Tower Bridge II** 1963

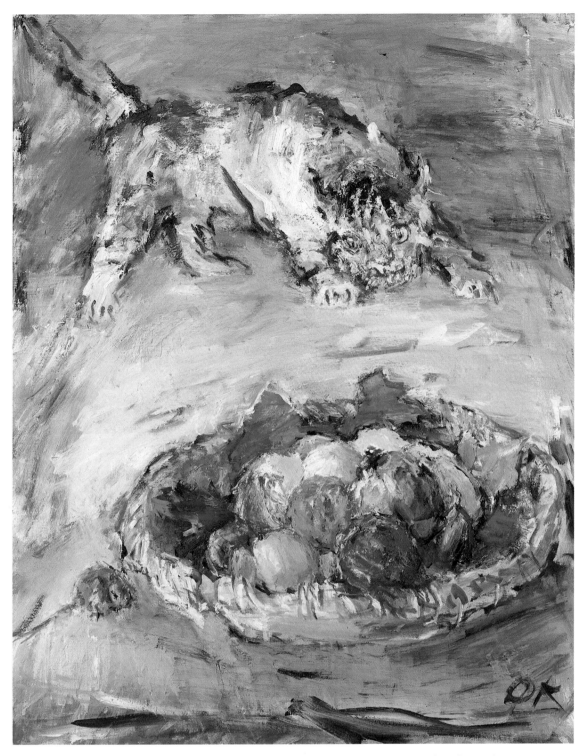

20 **Still Life with Cat** 1965

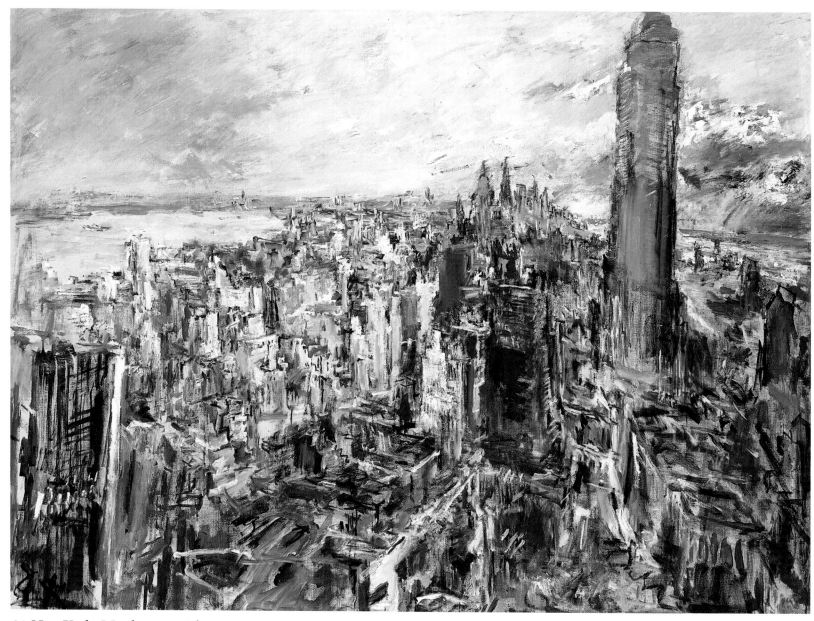

21 **New York, Manhattan with Empire State Building** 1966

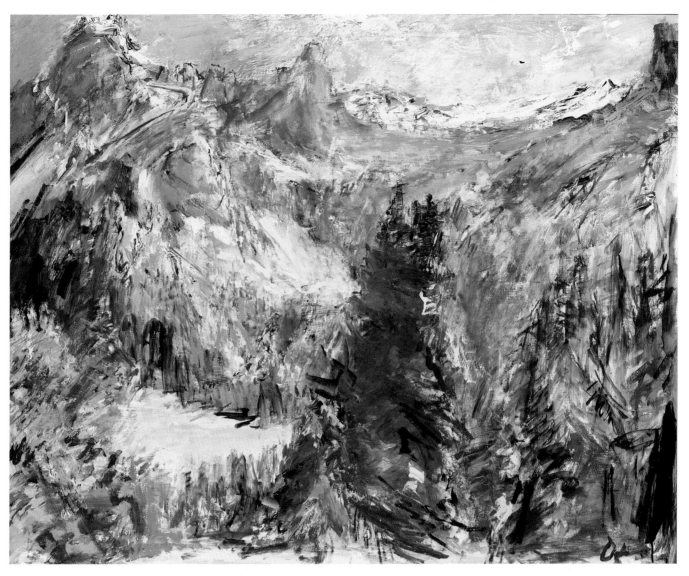

22 **Gstaad** 1967-68

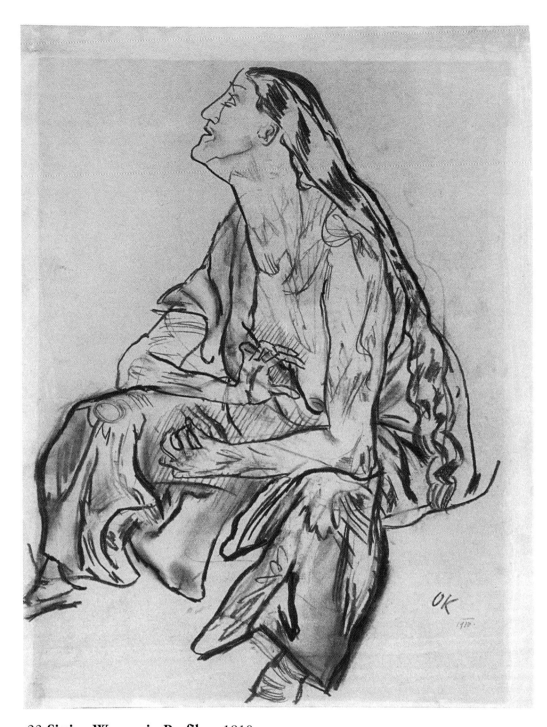

23 **Sitting Woman in Profile** 1910

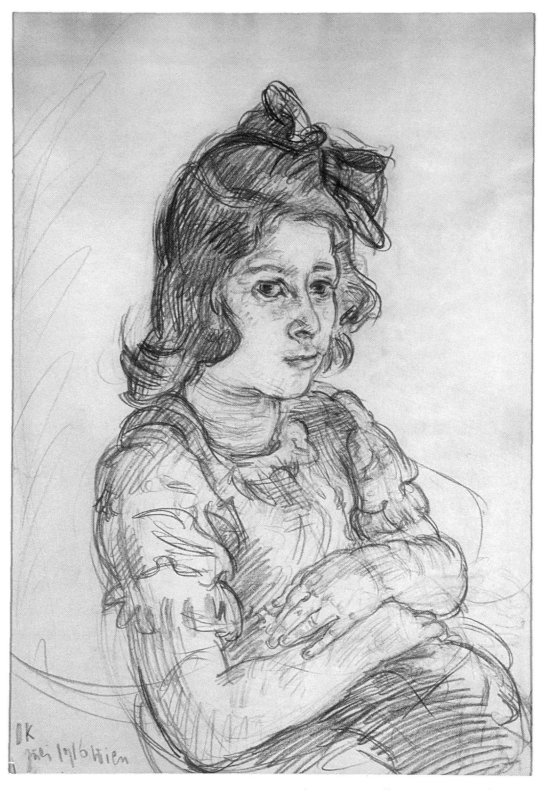

24 **Lotte Mandl as a Young Girl** 1916

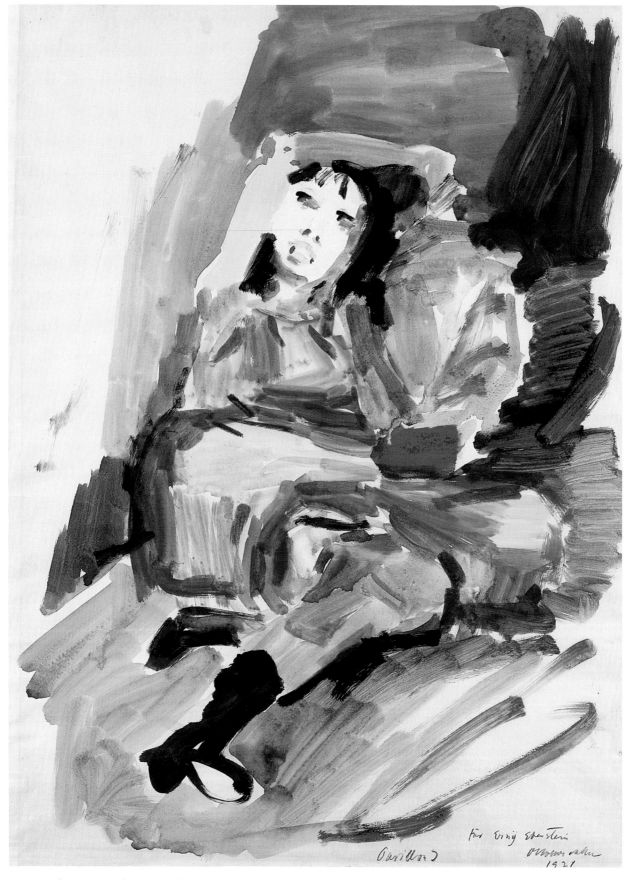

25 **Reclining Girl in a Red Dress** 1921

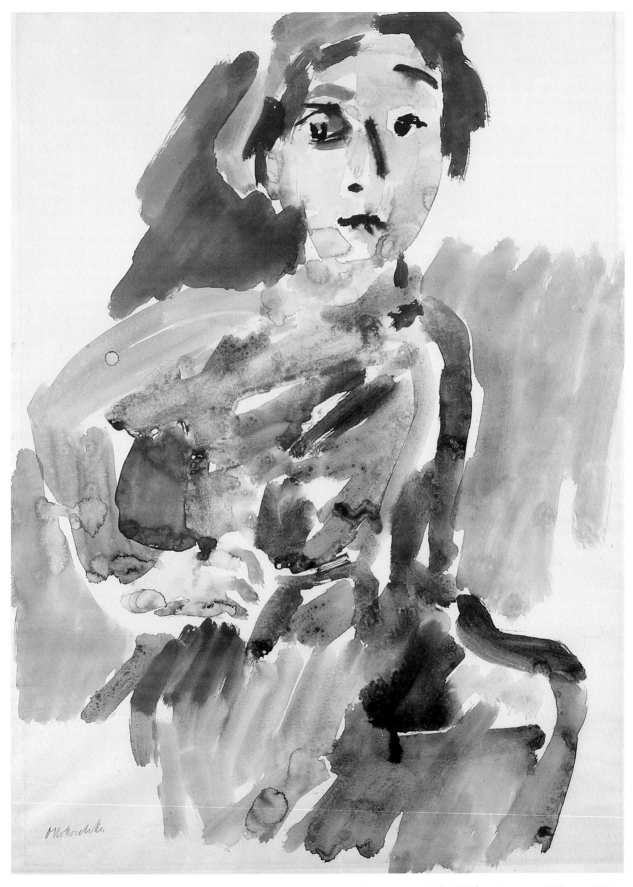

26 **Woman with Right Arm on Hip** 1921

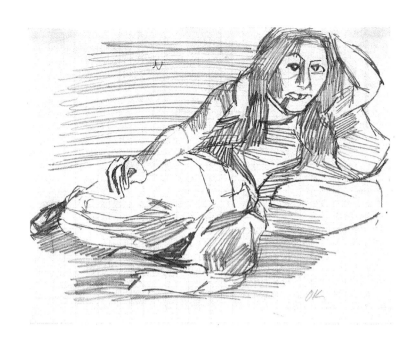

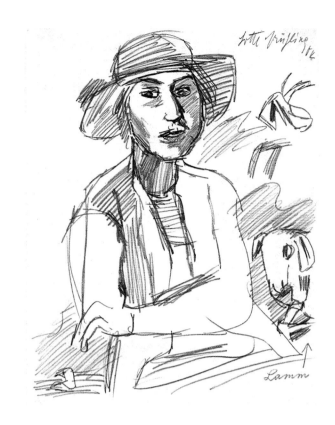

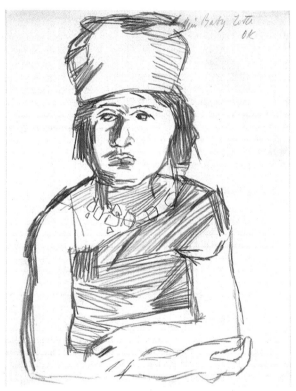

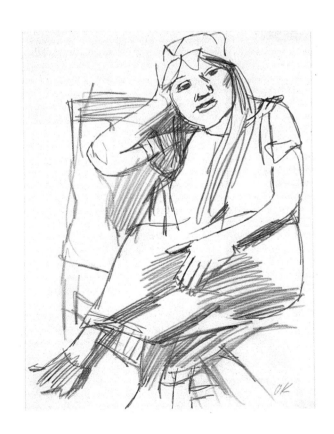

27 Group of 12 drawings of *Lotte Mandl* 1923-24

28 **Woman in Red Turban** 1924

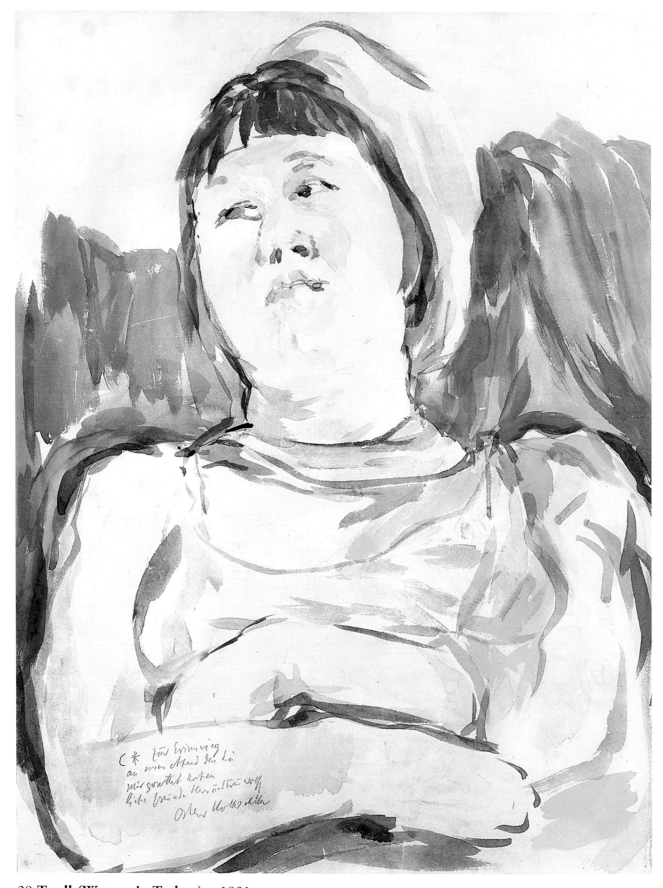

29 Trudl (Woman in Turban) 1931

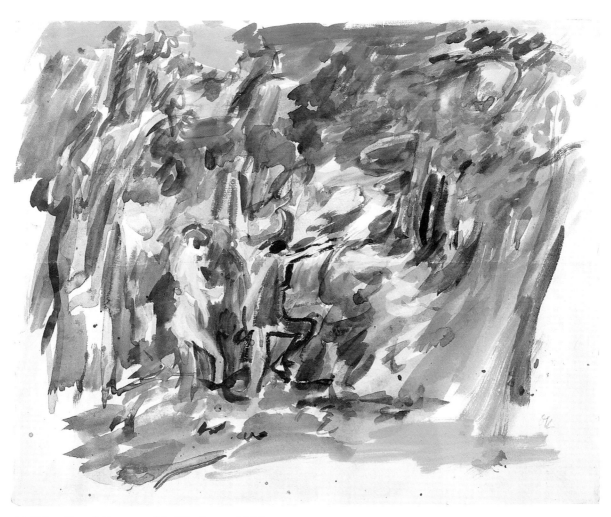

30 **Woodland Scene with Nudes** 1938

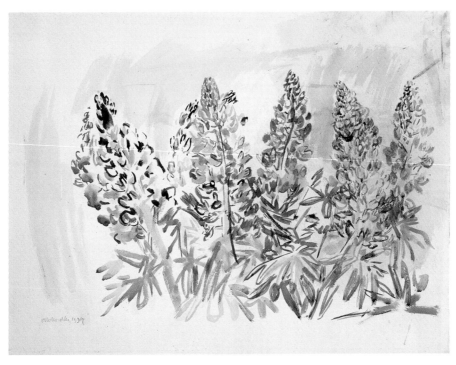

31 **Lupin** 1939

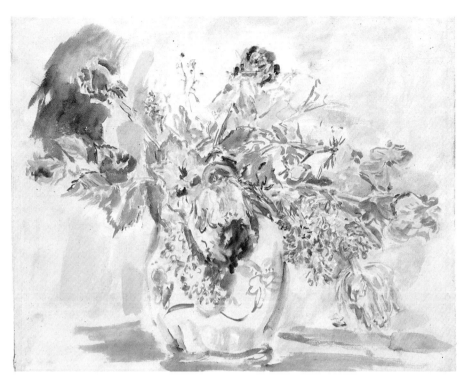

32 Mixed Flowers in a Chinese Vase 1940

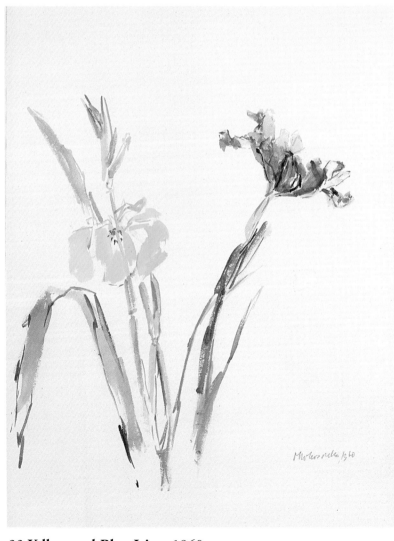

33 Yellow and Blue Iris 1960

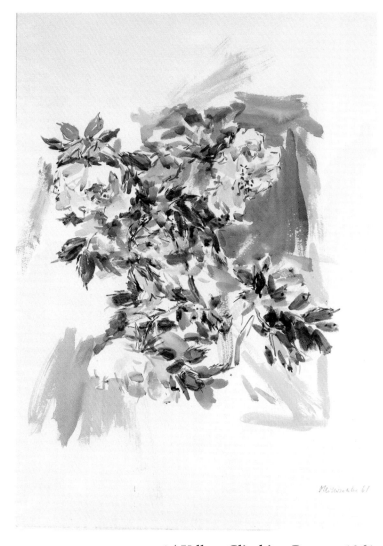

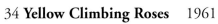

34 Yellow Climbing Roses 1961

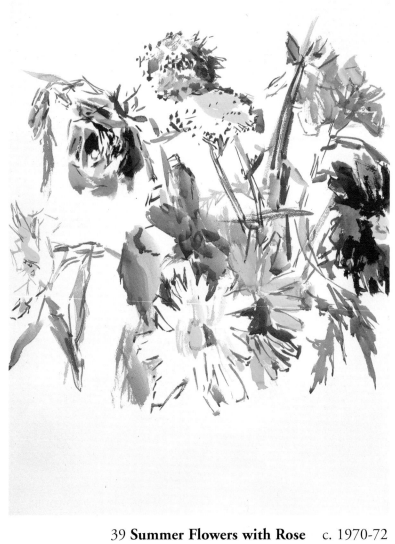

39 **Summer Flowers with Rose** c. 1970-72

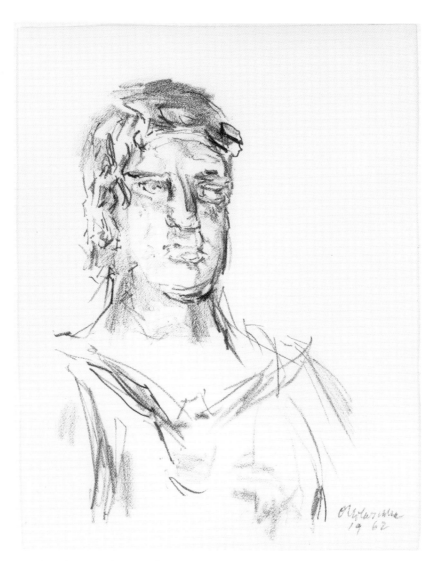

35 **Greek Female Head** 1962

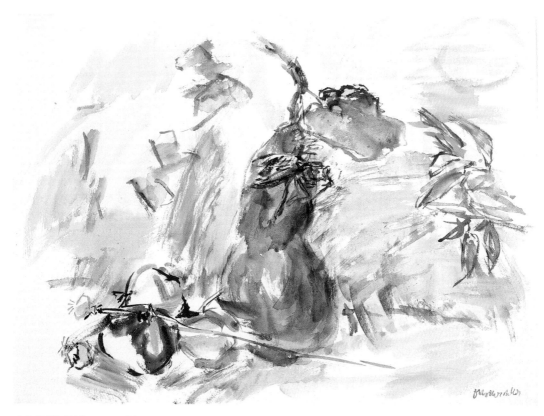

36 **Still Life** 1965

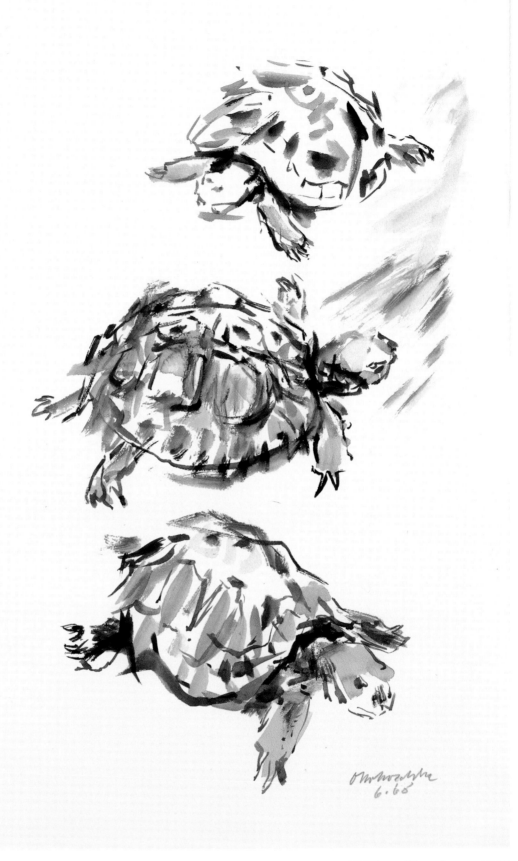

37 **Three Tortoises** 1968

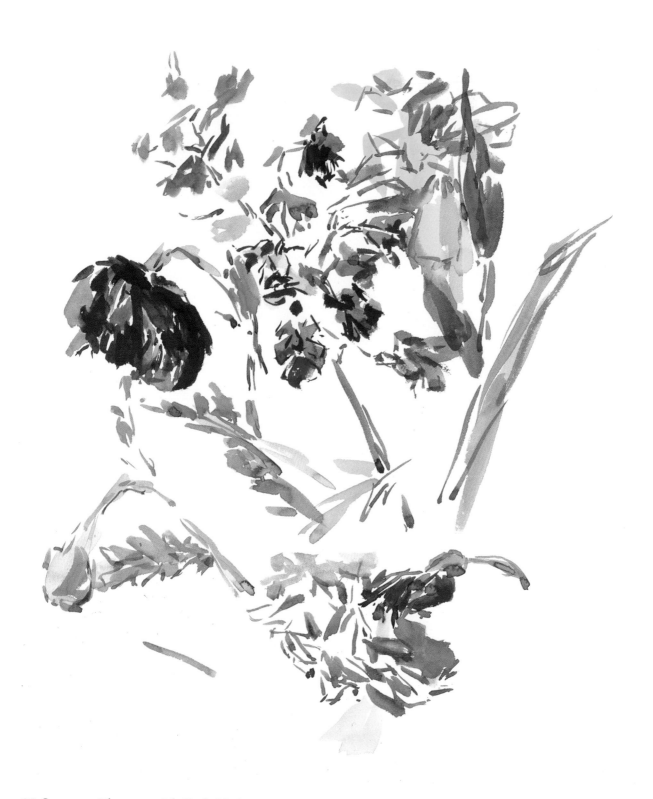

38 Summer Flowers with Delphinium c. 1970-72

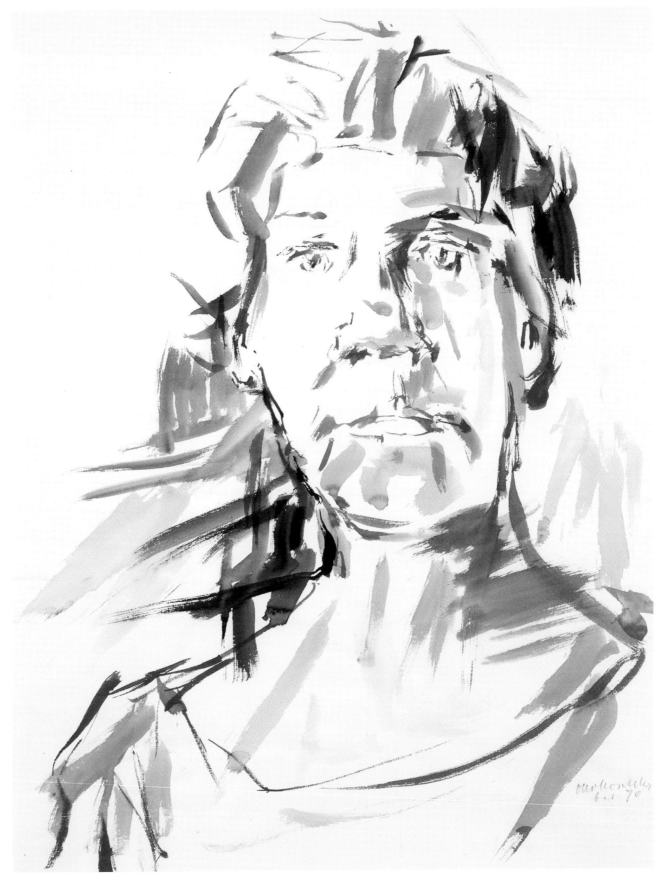

40 **Olda** 1970

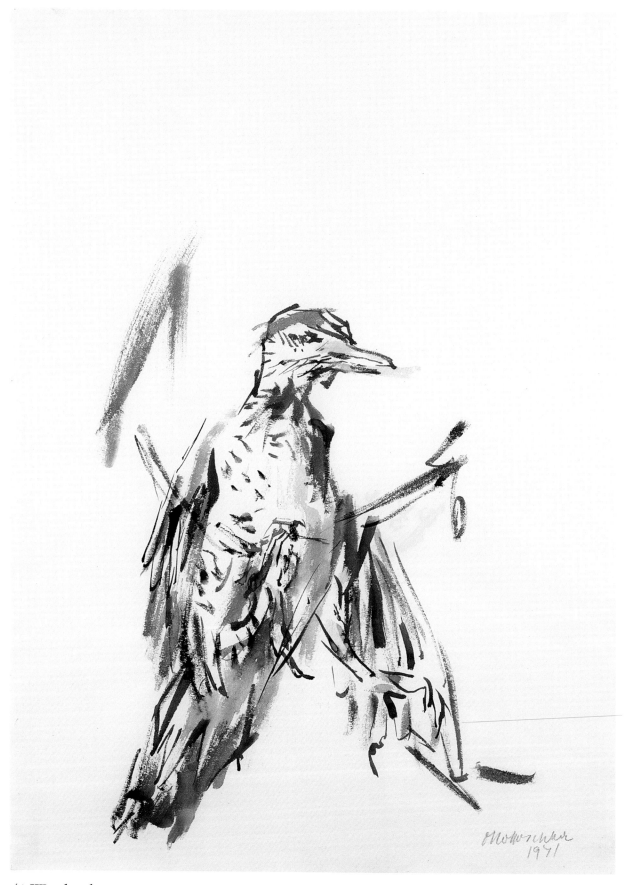

41 **Woodpecker** 1971

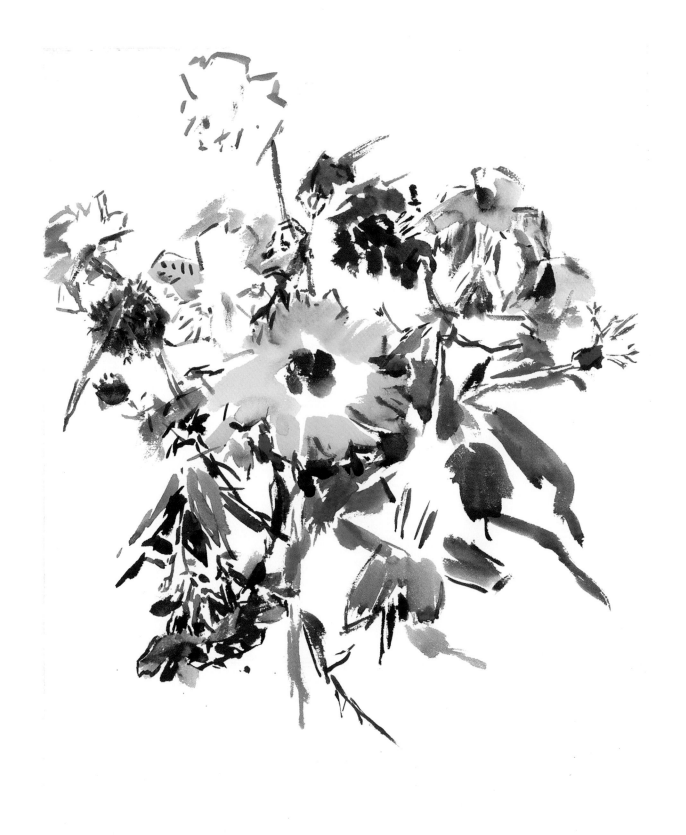

42 **Mixed Flowers** 1972

CATALOGUE OF WORKS
all works are oil on canvas unless otherwise stated
height precedes width

1. *Illustrated in color page 8*
Ludwig, Ritter von Janikowski 1909
23.7 x 21.7 in / 60.2 × 55.2 cm
signed upper right: OK
inscribed and dated on reverse: 14.X.09 Steinhof

Collection: Private Collection, New York

Provenance:
Adolf Loos, Vienna
Neue Galerie, Vienna
Fritz Wolff, Vienna/New York
Private Collection, New York

Exhibitions:
X. Ausstellung Paul Cassirer, Galerie Paul Cassirer, Berlin,
 June–July 1910
Oskar Kokoschka, Folkwang Museum, Hagen, August 1910
Kollektiv – Ausstellung Oskar Kokoschka, Karlsbad, Café "Park
 Schönbrunn", July–August 1911, no. 13
Sonderausstellung Malerei und Plastik, Hagenbund, Vienna,
 February 1911, no. 50
Mai Ausstellung, Kunsthaus, Zurich, May–June 1913, no. 139
Panama – Pacific International Exposition, Palace of Fine Arts,
 San Francisco, August 1915, no.316 (listed as: Portrait Dr.de
 Jankosy)
Oskar Kokoschka and Jacoba van Heemskerck, Bruno's Garret,
 Washington Square, New York, October 1915
Oskar Kokoschka II. Teil, Neue Galerie, Vienna, October 1924
*Oskar Kokoschka: Gemälde, Handzeichnungen, Aquarelle und
 Drucke,* Galerie Ernst Arnold, Dresden, January–February
 1925, no. 7
Internationale Kunstausstellung, Kunsthaus, Zurich,
 August–September 1925, no. 223
Kokoschka Ausstellung, Kunstsalon Herman Abels, Cologne,
 March–April 1929, no. 36
Oskar Kokoschka, Österreichisches Museum für Kunst und
 Industrie, Vienna, May–June 1937, no. 6, illustrated
Oskar Kokoschka Retrospective, Institute of Contemporary Art,
 Boston, October–November 1948, no. 8, illustrated
Oskar Kokoschka, The Arts Club, Chicago, October 1956, no.2
Oskar Kokoschka: Paintings, The Bayer Gallery, New York,
 January–February 1954, no. 2
Van Gogh and Expressionism in Modern Art, The Solomon R.
 Guggenheim Museum, New York, July–September 1964
Oskar Kokoschka (1886–1980), Memorial Exhibition,
 Marlborough-Gerson Gallery, New York, October–November
 1976, no. 7, illustrated
Oskar Kokoschka (1886–1980), Marlborough Gallery, New
 York, May–June 1981, no. 5, illustrated, (travelling to
 Marlborough Fine Art, London in June–July 1981)

Oskar Kokoschka, The Early Years 1907–1924, Serge Sabarsky
 Gallery, New York, December 1985–January 1986, no. 2,
 illustrated
Vienna 1900, Museum of Modern Art, New York, July–October
 1986, no. 65, illustrated
Oskar Kokoschka: Dipinti e disegni, Palazzo Medici-Riccardi,
 Florence, April–June 1987, no.2, illustrated
Europalia '87 Österreich, Museum voor Schone Kunsten, Ghent,
 September–November 1987, no. 6, illustrated
Oskar Kokoschka 1886–1980, Museu Picasso, Barcelona,
 February–April 1988, no. 6, illustrated
Oskar Kokoschka, Kunstforum Länderbank, Vienna,
 March–June 1991, no. 8, illustrated
Das XX. Jahrhundert – Ein Jahrhundert Kunst in Deutschland,
 Neue Nationalgalerie, Berlin, September 1999–January 2000,
 catalogue no. 245, illustrated page 265 and 273

Literature:
Hans Maria Wingler, <u>Oskar Kokoschka, The Work of the Painter,</u>
 Verlag Galerie Welz, Salzburg, 1958, no. 27, illustrated page 296
Johann Winkler and Katharina Erling, <u>Oskar Kokoschka, Die
 Gemälde 1906–1929,</u> Verlag Galerie Welz, Salzburg, 1995,
 no. 17, page 14 and 15, illustrated in color page 14

2. *Illustrated in color page 9 / not in exhibition*
Conte Verona 1910
27.8 x 23.1 in / 70.6 × 58.7 cm
signed lower right with initials: OK

Provenance:
Adolf Loos, Vienna
Neue Galerie, Vienna
Fritz Wolff, Vienna/New York
Annie Knize, New York
Private Collection, USA

Exhibitions:
X Ausstellung Paul Cassirer, Galerie Paul Cassirer, Berlin,
 June–July 1910, catalogue no. 8
Oskar Kokoschka, Folkwang Museum, Hagen, August, 1910
Sonderausstellung Malerei und Plastik,
 Hagenbund, Vienna, February, 1911, no. 49
Kollektiv – Ausstellung Oskar Kokoschka, Karlsbad, Café "Park
 Schönbrunn", July–August 1911, no. 12
Mai Ausstellung, Kunsthaus, Zurich, May–June 1913, no. 136
Panama – Pacific International Exposition, Palace of Fine Arts,
 San Francisco, August 1915, no. 315
Oskar Kokoschka and *Jacoba Heemskerck,* Bruno's Garret,
 Washington Square, New York, October 1915
Oskar Kokoschka II. Teil, Neue Galerie, Vienna, October 1924
*Oskar Kokoschka: Gemälde, Handzeichnungen, Aquarelle und
 Drucke,* Galerie Ernst Arnold, Dresden, January–February
 1925, no. 2
Internationale Kunstausstellung, Kunsthaus, Zurich,
 August–September 1925, no. 226

Bildnisse von Oskar Kokoschka: Menschen und Tiere, Galerie Paul
 Cassirer, Berlin, February 1927, no. 10
O. Kokoschka Retrospective, Institute of Contemporary Art,
 Boston, October–November 1948, no. 12, illustrated
Oskar Kokoschka, The Bayer Gallery, New York,
 January–February 1954, loan exhibition, no. 5
Paintings by Oskar Kokoschka, California Museum of Art, Santa
 Barbara, February–March 1954, no. 4 (travelling to: The
 California Palace of the Legion of Honor, San Francisco,
 March–April, 1954)
Oskar Kokoschka: Paintings, The Arts Club, Chicago, October
 1956, no. 3
Oskar Kokoschka, Marlborough-Gerson Gallery, New York,
 October–November 1966, no. 9, illustrated
Expressionisten, Serge Sabarsky Gallery, New York, 1972, no. 42,
 illustrated
Oskar Kokoschka (1886–1980) Memorial Exhibition,
 Marlborough Gallery, New York, May–June 1981 (travelling
 to Marlborough Fine Art, London, June–July 1981), no. 7,
 illustrated
Oskar Kokoschka 1886–1980, Palazzo Venezia, Rome,
 November 1981–February 1982, illustrated in color
Oskar Kokoschka 1886–1980, Tate Gallery, London,
 June–August 1986, no. 14, illustrated in color (travelling to
 Kunsthaus Zurich, September–November 1986; Guggenheim
 Museum, New York December 1986–February 1987)
Oskar Kokoschka: Dipinti e disegni, Palazzo Medici-Riccardi,
 Florence, April–June 1987, no. 3, illustrated
Europalia '87 Österreich, Museum voor Schone Kunsten, Ghent,
 September–November 1987, no. 7, illustrated (travelling to
 Liège, Salle Saint Georges, November–December 1987)
Oskar Kokoschka 1886–1980, Museu Picasso, Barcelona,
 February–April 1988, no. 7, illustrated
Oskar Kokoschka, Kunstforum Länderbank, Vienna,
 March–June 1991, no. 9, illustrated
Das XX. Jahrhundert – Ein Jahrhundert Kunst in Deutschland,
 Neue Nationalgalerie, Berlin, September 1999–January, 2000,
 catalogue no. 246, illustrated page 273

Literature:
Hans Maria Wingler, <u>Oskar Kokoschka, The Work of the Painter,</u>
 Verlag Galerie Welz, Salzburg, 1958, no. 32, illustrated page 297
Johann Winkler and Katharina Erling, <u>Oskar Kokoschka,</u>
 <u>Die Gemälde 1906–1929,</u> Verlag Galerie Welz, Salzburg
 1995, no. 41, page 23 and 24, illustrated in color page 24

3. *Illustrated in color page 10*
Anton von Webern 1914
24.5 x 19 in / 62.2 x 48.2 cm

Provenance:
Adolf Loos, Vienna
Neue Galerie, Vienna
Fritz Wolff, Vienna / New York
Annie Knize, New York
Private Collection, U.S.A.

Exhibitions:
Oskar Kokoschka - Jacoba van Heemskerck, Bruno's Garret,
 Washington Square, New York, October 1915
Panama-Pacific International Exposition, Palace of Fine Arts,
 San Francisco, August 1915, no. 312
*Oskar Kokoschka, Gemälde, Handzeichnungen, Aquarelle und
 Drucke,* Galerie Ernst Arnold, Dresden, January - February
 1925, no. 28
Oskar Kokoschka, Haus der Kunst, Munich, March - May
 1958, no. 39
Oskar Kokoschka, Künstlerhaus, Vienna, May - June 1958, no. 39
Oskar Kokoschka, Bayer Gallery, New York, January -
 February 1959, no. 8
Oskar Kokoschka, Marlborough-Gerson Gallery, New York,
 October - November 1966, no.17, illustrated
Oskar Kokoschka, The Early Years 1907-1924, Serge Sabarsky
 Gallery, New York, December 1985 - January 1986, no. 7,
 illustrated
Egon Schiele und Wien zur Jahrhundertwende, Isetan Museum,
 Shinjuku, Tokyo, March - April 1986, no. 108, illustrated
Oskar Kokoschka, Dipinti e disegni, Palazzo Medici-Riccardi,
 Florence, April - June 1987, no.5, illustrated
Europalia '87 Österreich, Museum voor Schone Kunsten,
 Ghent, September - November 1987, no. 12, illustrated
Oskar Kokoschka 1886-1980, Museu Picasso, Barcelona,
 February - April 1988, no. 12, illustrated
Oskar Kokoschka, Kunstforum Länderbank, Vienna, March -
 June 1991, no. 28, illustrated
Richard Gerstl - Oskar Kokoschka, Galerie St. Etienne, New
 York, March - May 1992, no. 44

Literature:
Hans Maria Wingler, <u>Oskar Kokoschka, The Work of the
 Painter,</u> Verlag Galerie Welz, Salzburg, 1958, no. 99, page 305
Johann Winkler and Katharina Erling, <u>Oskar Kokoschka Die
 Gemälde 1906 - 1929,</u> Verlag Galerie Welz, Salzburg, 1995
 no. 111, page 66 and 67, illustrated in color page 66

4. *Illustrated in color on cover and page 11*
Arnold Schönberg 1924
39.2 x 29.8 in / 99.4 x 75.6 cm
signed upper left: OK

Provenance:
Fritz Wolff, Vienna/New York
Annie Knize, New York
Private Collection, U.S.A.

Exhibitions:
Ernste Musik von Anton Bruckner bis zur jüngsten Gegenwart,
 Museum der Stadt Wien, Vienna, Music Festival, 1924
43. Jahresausstellung der Genossenschaft der Bildenden Künstler
 Wiens, Künstlerhaus, Vienna, April - June 1926, no. 440,
 illustrated
Bildnisse von Oskar Kokoschka, Galerie Paul Cassirer, Berlin,
 February 1927, no. 29
Ausstellung Oskar Kokoschka, Kunsthaus, Zurich, June - July
 1927, no. 67
Oskar Kokoschka: A Retrospective Exhibition, Institute of
 Contemporary Art, Boston, October - November 1948, no.
 32, illustrated. Traveled to: Phillips Memorial, Washington
 DC, December 1948-January 1949; M.H. de Young
 Memorial Museum, San Francisco, April - May 1949;
 Delaware Art Centre, Wilmington, June - July 1949;
 Museum of Modern Art, New York, July - October 1949
Paintings by Oskar Kokoschka, Museum of Art, Santa Barbara,
 February - March 1954, no.10
Oskar Kokoschka, Haus der Kunst, Munich, March - May
 1958, no. 60
Oskar Kokoschka, Künstlerhaus, Vienna, May - June 1958, no. 58
Oskar Kokoschka, Bayer Gallery, New York, January - February
 1959, no. 11
Oskar Kokoschka, Tate Gallery, London, September -
 November 1962, no. 74, illustrated
Oskar Kokoschka, Kunstverein, Hamburg, December 1962 -
 January 1963, no. 38, illustrated
Artist and Maecenas, A Tribute to Curt Valentin, Marlborough-
 Gerson Gallery, New York, November - December 1963, no.
 245, illustrated
Oskar Kokoschka, Das Porträt, Badischer Kunstverein,
 Karlsruhe, August - November 1966, no. 37, illustrated
Oskar Kokoschka, Marlborough-Gerson Gallery, New York,
 October - November 1966, no. 30, illustrated
Arnold Schönberg, Sezession, Vienna, May - June 1974, no. 361
Oskar Kokoschka (1886-1980), Marlborough Gallery, New
 York, May - June 1981, no. 21, illustrated; Marlborough
 Fine Art, London, June - July 1981
Oskar Kokoschka 1886-1980, Palazzo Venezia, Rome,
 November 1981 - February 1982, illustrated in color
Oskar Kokoschka: The Early Years 1907-1924, Serge Sabarsky
 Gallery, New York, December 1985 - January 1986, no.8,
 illustrated
Vienne 1880-1938, Centre National d'Art et de Culture
 Georges Pompidou, Paris, February - May 1986

Oskar Kokoschka 1886-1980, The Solomon R. Guggenheim
 Museum, New York, December 1986 - February 1987, no.
 43, illustrated
Oskar Kokoschka Dipinti e disegni, Palazzo Medici-Riccardi,
 Florence, April - June 1987, no. 8, illustrated
Europalia '87 Österreich, Museum voor Schone Kunsten,
 Ghent, September - November 1987, no. 21, illustrated
Oskar Kokoschka 1886-1980, Museu Picasso, Barcelona,
 February - April 1988, no. 22, illustrated
Oskar Kokoschka, Kunstforum Länderbank, Vienna, March -
 June 1991, (ex-catalogue)
Richard Gerstl - Oskar Kokoschka, Galerie St. Etienne, New
 York, March - May 1992, no. 64

Literature:
Hans Maria Wingler, <u>Oskar Kokoschka, The Work of the Painter,</u>
 Verlag Galerie Welz, Salzburg, 1958, no. 171, page 312
Johann Winkler and Katharina Erling, <u>Oskar Kokoschka: Die</u>
 <u>Gemälde 1906 - 1929</u>, Verlag Galerie Welz, Salzburg 1995,
 no. 178, page 105, illustrated in color page 105

5. *Illustrated in color page 12*
Madrid, Plaza Canovas del Castillo 1925
(formerly known as *Madrid, Puerta del Sol*)
26.4 x 39.3 in / 67 x 99.7 cm
signed lower left: OK

Provenance:
Galerie Paul Cassirer, Berlin, 1925; jointly owned with
Galerie M. Goldschmidt & Co., Frankfurt
Galerie Georg Caspari, Munich, 1925
Max Glaeser, Eselfürth, Bavaria
Galerie Paul Cassirer, Berlin, 1931
Paul Cassirer & Co., Amsterdam, 1931
Galerie Fischer, Lucerne
Private Collection, Switzerland

Exhibited:
Landschaften von Oskar Kokoschka, Galerie Paul Cassirer,
 Berlin, November 1925, catalogue no. 30; Galerie M.
 Goldschmidt, Frankfurt, December 1925
Ausstellung Oskar Kokoschka, Kunsthaus, Zurich, June - July
 1927, no. 80
Oskar Kokoschka, Städtische Kunsthalle, Mannheim, January -
 March, 1931, no. 52
Oskar Kokoschka, Galerie Georges Petit, Paris, March - April
 1931, no. 12
Exhibition of 20th Century German Art, New Burlington
 Galleries, London, July 1938, no. 106
Oskar Kokoschka, Kunsthalle, Basel, March - April, 1947, no. 143
Oskar Kokoschka, Kunsthaus, Zurich, July - August, 1947, no. 25
Oskar Kokoschka in het Stedelijk Museum, Amsterdam,
 November - December 1947, no. 21
Deutsche Kunst, Kunstmuseum, Lucerne, July - October 1953,
 no. 195

Oskar Kokoschka, Gemeentemuseum, The Hague, July - October 1958, no. 48

Oskar Kokoschka, Haus der Kunst, Munich, March - May 1958, no. 72, illustrated page 50; Künstlerhaus, Vienna, May - June 1958, no. 70, illustrated page 50

Oskar Kokoschka 1886-1980, Tate Gallery, London, September - November 1962, no. 85

Oskar Kokoschka, Kunstverein, Hamburg, December 1962 - January 1963, no. 43, illustrated

Oskar Kokoschka, Kunsthaus, Zurich, June - July 1966, no. 83

Oskar Kokoschka Städteporträts, Österreichisches Museum für angewandte Kunst, (Austrian Museum of Applied Arts), Vienna, March - April 1986, pp 118-119, illustrated in color

Literature:

Paul Westheim, <u>Oskar Kokoschka,</u> Paul Cassirer, Berlin, 1925, illustrated in the appendix "Reise nach Südfrankreich und Spanien 1925"

Hans Heilmaier, <u>Kokoschka,</u> Crès, Paris, 1929, illustrated no. 18

Wolfgang Born, <u>Deutsche Kunst und Dekoration,</u> "Neue Bilder von Oskar Kokoschka", Darmstadt, 1930, no. 67, illustrated page 83

Edith Hoffmann, <u>Kokoschka: Life and Work,</u> Faber & Faber, London, 1947, page 185

Hans Maria Wingler, <u>Oskar Kokoschka - The Work of the Painter,</u> Verlag Galerie Welz, Salzburg, 1958, reproduced plate 75, no. 194, page 314

Bernhard Bultmann, <u>Oskar Kokoschka,</u> Verlag Galerie Welz, Salzburg, 1959. page 76, illustrated in color pl. 16

Helge Ernst, Fritz Schmalenbach & Kenneth Clark, <u>Marc Chagall - Oskar Kokoschka,</u> Copenhagen, 1960, illustrated in color but not exhibited

Epoca, Munich, 1967, September issue no. 9, illustrated page 49

<u>Oskar Kokoschka - Mein Leben,</u> Bruckmann Verlag, Munich, 1971, page 203

Edwin Lachnit, <u>Oskar Kokoschka 1991 "Der Mensch hat zwei Augen - Die Städtebilder ab 1923",</u> page 33, illustrated no. 4

Johann Winkler and Katharina Erling, <u>Oskar Kokoschka - Die Gemälde 1906 - 1929,</u> Verlag Galerie Welz, Salzburg, 1995, no. 203, illustrated in color page 117

6. *Illustrated in color page 13*
London, Large Thames View I 1926
35.5 x 51.3 in / 90.2 x 130.2 cm
signed lower left: OK

Collection: Albright-Knox Art Gallery, Buffalo, New York

Provenance:
Galerie Paul Cassirer, Berlin
Ludwig Katzenellenbogen, Berlin
Neue Galerie (Otto Nierenstein), Vienna
Galerie St. Etienne (Otto Kallir - Nierenstein), New York
Albright-Knox Art Gallery, Buffalo, New York

Exhibited:
Oskar Kokoschka, Kunsthaus, Zurich, June - July 1927, catalogue no. 85

Oskar Kokoschka, Leicester Galleries, London, June 1928, catalogue no. 8

Oskar Kokoschka. Gemälde, Aquarelle und Zeichnungen, Neue Galerie, Vienna, October 1932

Meisterwerke moderner österreichischer Malerei, Neue Galerie, Vienna, July - September 1933

Oskar Kokoschka, Galerie Hugo Feigel, Prague, December 1933 - January 1934, catalogue no. 7

Werke von Oskar Kokoschka, Hans Pilhs und Anton Steinhart, Kunsthandlung Friedrich Welz, Salzburg, August - September 1935

Österreichische Kunst im 20. Jahrhundert, Kunsthalle, Berne, August - September 1937, catalogue no. 86

Exposition d'art autrichien, Musée du Jeu de Paume des Tuileries, Paris, April - June 1937, catalogue no. 536

Oskar Kokoschka, Galerie St. Etienne, New York, April - May 1939

Oskar Kokoschka, Galerie St. Etienne / Buchholz Gallery, New York, January - February 1940, catalogue no. 15

Oskar Kokoschka, The Arts Club of Chicago, January 1941, catalogue no. 16

Paintings, Watercolors, Drawings and Lithographs by Oskar Kokoschka, City Art Museum, St. Louis, October 1942, catalogue no. 5

Oskar Kokoschka, Institute of Contemporary Art, Boston, November 1948, catalogue no. 39; traveled to: Phillips Memorial Gallery, Washington, December 1948 - January 1949; City Art Gallery, St. Louis, February - March 1949; M.H. de Young Memorial Museum, San Francisco, April - May 1949; Delaware Art Center, Wilmington, June - July 1949; Museum of Modern Art, New York, July - October 1949

The Painter and the City, New Gallery of the Charles Hayden Memorial Library (organized by the Massachusettes Institute of Technology), Cambridge, May - June 1950

German Art of the Twentieth Century, Museum of Modern Art New York, October - December 1957, travelling to: City Art Museum, St. Louis, January - February 1958, catalogue no. 103, color illustration page 81

Oskar Kokoschka, Gemeentemuseum, The Hague, July - October 1958, catalogue no. 50

Oskar Kokoschka, Haus der Kunst, Munich, March - May 1958, catalogue no. 76, page 53

Oskar Kokoschka, Künstlerhaus, Vienna, May - July 1958, catalogue no. 74 page 53

Oskar Kokoschka in England and Scotland, Marlborough Fine Art, London, June - August 1960, catalogue no. 3

Kokoschka, Tate Gallery, London, September - November 1962, catalogue no. 92

Oskar Kokoschka, Davison Art Center, Wesleyan University, Middletown, April 1964

Oskar Kokoschka, Marlborough-Gerson Gallery, New York, October - November 1966, catalogue no. 27, page 57

Oskar Kokoschka, Kunsthaus, Zurich, June - July 1966, catalogue no. 55

Paintings from the Albright-Knox Art Gallery, Buffalo, New York, National Gallery of Art, Washington DC, May - July 1968, page 41

109 Obras de Albright-Knox Art Gallery, Museo Nacional de Bellas Artes, Buenos Aires, October - November 1969, catalogue no. 38

The Impressionists in London, Hayward Gallery, London, January - March 1973, catalogue no. 58, page 73

Oskar Kokoschka 1886 -1980, Tate Gallery, London, June - August, catalogue no. 59, travelling to: Kunsthaus, Zurich, Sept - Nov 1986 catalogue no 60 ; Solomon R. Guggenheim Museum, New York, December 1986 - February 1987, catalogue no. 47

Richard Gerstl - Oskar Kokoschka, Galerie St. Etienne, New York, March - May 1992, catalogue no. 66

Literature:

Georg Biermann, Oskar Kokoschka, Klinkhardt & Biermann, Leipzig / Berlin, 1929, illllustration no. 27

Hans Heilmaier, Kokoschka, Crès, Paris, 1929, illustration no. 25

Die Bühne, Vienna, 1934, October issue, illustrated page 18.

Alfred Neumeyer, Oskar Kokoschka, in: *Magazine of Art,* Washington DC, 1945, Volume 38, no. 7, page 265, illustrated

Hans Platschek, Oskar Kokoschka, Edition Poseidon, Buenos Aires, 1946, illustration no. 30

Edith Hoffmann, Kokoschka: Life and Work, Faber & Faber, London, 1947, catalogue no. 205, page 186, 198

Andrew C. Ritchie, Catalogue of Contemporary Paintings and Sculpture, Albright Knox Art Gallery, Buffalo, 1949, page 60 - 61, illustrated page 202, no. 51

Joseph P. Hodin, Expressionism, in: *Horizon,* Volume 19, no. 109, London, 1949, illustrated opposite page 44

Hans Maria Wingler, Oskar Kokoschka, Das Werk des Malers, Verlag Galerie Welz, Salzburg, 1956, catalogue no. 208, page 316

Bernhard Bultmann, Oskar Kokoschka, Verlag Galerie Welz, Salzburg, 1959, page 80, illustrated as color plate 18

John Canaday, Mainstreams of Modern Art, Simon and Schuster, New York, 1959, page 439, illustration no. 533

Georg Schmidt, Die Malerei in Deutschland 1918-1955, Langewiesche, Königstein/Taunus, 1960, color illustration page 22

Ludwig Goldscheider, Kokoschka, Phaidon Verlag, Cologne, 1963, page 77, color illustration plate 29

Edith Hoffmann, Kokoschka, Medici Society, London, 1964, page 11, illustrated on cover of catalogue and on plate 6

Werner Hofmann, Moderne Malerei in Österreich, Kunstverlag Wolfrum, Vienna, 1965, page 166 and 168, color illustration plate 61

Joseph P. Hodin, Oskar Kokoschka, The Artist and His Time, New York Graphic Society, Greenwich, 1966, illustration no. 31

Fritz Schmalenbach, Oskar Kokoschka, Langewiesche, Königstein/Taunus, 1967, illustrated in color plate 63

Curt Seckel, Maßstäbe der Kunst im 20. Jahrhundert, Econ Verlag, Vienna/Dusseldorf, 1967, page 91, illustration no. 8, opposite page 72

Joseph P. Hodin, Oskar Kokoschka, Europa Verlag, Vienna, 1971, illustrated page 235

Oskar Kokoschka, Mein Leben, Bruckman Verlag, Munich, 1971, (New York, 1974), page 206

Jan M. Tomeš, Oskar Kokoschka, Bruckmann Verlag, Munich, 1972, page 27-28, illustrated in color plate 29

Paintings and Sculpture from Antiquity to 1942, Albright Knox Art Gallery, Rizzoli, New York, 1979, page 384-385, illustrated page 385

Peter Selz, Art in Our Times, A Pictoral History 1890-1980, Abrams, New York, 1981, illustration no. 663

David Piper, Artists London, Weidenfeld & Nicholson, London, 1982, page 120 -122, illustrated page 124

H.H. Arnason, History of Modern Art, Abrams, New York, 1983, color illustration plate 104

Olda Kokoschka and Heinz Spielmann, Oskar Kokoschka Briefe 2, Claasen Verlag, Düsseldorf, 1985, page 152

125 Masterpieces from the Albright Knox Art Gallery, Rizzoli, New York, 1987, page 128, illustrated in color page 129

Norbert Werner, Kokoschka, Leben und Werk in Daten und Bilder, Insel Verlag, Leipzig, 1991, page 62, illustrated page 63

Richard Calvocoressi, Kokoschka, Paintings, Edizione Poligrafa, Barcelona 1992, color illustration no. 53

Jane Kallir, Richard Gerstl - Oskar Kokoschka, Galerie St. Etienne, New York, 1992, plate 59

Johann Winkler and Katharina Erling, Oskar Kokoschka, Die Gemälde 1906-1929, Verlag Galerie Welz, Salzburg, 1995, catalogue no. 223, page 127, illustrated in color page 127

7. *Illustrated in color page 14*
Fritz Wolff 1927
43.4 x 34.6 in / 110.2 x 88 cm
signed and dated lower left: OK 27

Provenance:
Fritz Wolff, Vienna / New York
Annie Knize, New York
Private Collection, U.S.A.

Exhibitions:
Ostenrijksche schilderijen en kunstnijverheid 1900-1927,
 Gemeentemuseum voor Schone Kunsten, The Hague,
 October - November 1927, no. 75
Ausstellung Oskar Kokoschka, Kunsthaus, Zurich, June - July
 1927, no. 99
*Austellung der Vereinigung der Bildenden Künstler Wiener
 Sezession,* Secession, Vienna, February - April 1929, illustrat-
 ed (listed as "Bildnis")
Oskar Kokoschka, Bayer Gallery, New York, January - February
 1959, no. 12, listed as "Frederick Knize"
Oskar Kokoschka, Marlborough-Gerson Gallery, New York,
 October - November 1966, no.38, illustrated
Oskar Kokoschka 1886-1980, Marlborough Gallery, New York,
 May - June 1981, no. 24, illustrated; Marlborough Fine Art,
 London, June-July 1981
Oskar Kokoschka 1886-1980, Tate Gallery, London, June -
 August 1986, no. 67, illustrated, travelling to: Kunsthaus,
 Zurich, September - November 1986, no. 69, illustrated;
 The Solomon R. Guggenheim Museum, New York,
 December 1986 - February 1987, no. 53, illustrated
Oskar Kokoschka Dipinti e disegni, Palazzo Medici-Riccardi,
 April - June 1987, no. 10, illustrated
Europalia '87 Österreich, Museum voor schone Kunsten,
 Ghent, September - November 1987, no. 27, illustrated
Oskar Kokoschka 1886-1980, Museu Picasso, Barcelona,
 February - April 1988, no. 31, illustrated

Literature:
Hans Maria Wingler, Oskar Kokoschka, The Work of the Painter,
 Verlag Galerie Welz, Salzburg, 1958, no. 225, page 317
Johann Winkler and Katharina Erling, Oskar Kokoschka Die
 Gemälde 1906 - 1929, Verlag Galerie Welz, Salzburg, 1995,
 no. 237, page 134 and 135, illustrated in color page 134

8. *Illustrated in color page 15*
Lyon 1927
38.4 x 51.3 in / 97.5 x 130.2 cm
signed lower left: OK

Collection: The Phillips Collection, Washington DC

Provenance:
Galerie Paul Cassirer, Berlin
Estella Katzenellenbogen, Berlin / Santa Monica, California
The Phillips Collection, Washington DC

Exhibited:
Oskar Kokoschka, Leicester Galleries, London, June, 1928, no. 4
Oskar Kokoschka, Das gesammelte Werk, Städtische
 Kunsthalle, Mannheim, January - March 1931, no. 68
Oskar Kokoschka, Galerie Georges Petit, Paris, March - April
 1931, no. 31
Frühjahrsausstellung, Neue Galerie, Vienna, October 1932
Sammlung 1910-1935, Kunsthaus, Zurich, April-May 1935,
 no. 85
Oskar Kokoschka, Österreichisches Museum, Vienna, May -
 June 1937, Page 7, no. 16, illustrated
Oskar Kokoschka, Genootschap Kunstliefde, Utrecht, February
 - March 1939, no. 5
Oskar Kokoschka, Stedelijk Museum, Amsterdam, November -
 December 1947, no. 26
Oskar Kokoschka, Kunsthalle, Basel, March - April 1947, no.
 138, illustrated
Oskar Kokoschka, Kunsthaus, Zurich, July - August 1947, no. 31
Oskar Kokoschka, A Retrospective Exhibition, Institute of
 Contemporary Art, Boston, October - November 1948, no. 44,
 illustrated
Oskar Kokoschka, Gemeentemuseum, The Hague, July -
 October 1958, no. 60
Oskar Kokoschka, Haus der Kunst, Munich, March - May
 1958, no. 88, illustrated page 57
Oskar Kokoschka, Künstlerhaus, Vienna, May - July 1958, no.
 84, illustrated page 57
Kokoschka, Tate Gallery, London, September - November 1962, no. 101
Oskar Kokoschka, Marlborough-Gerson Gallery, New York,
 October - November 1966, no. 40, illustrated page 60
Master Paintings from the Phillips Collection, The Fine Arts
 Museum of San Francisco, July - November 1981, no. 34,
 illustrated in color page 103
Oskar Kokoschka 1886-1980, Galerie des Beaux-Arts, Bordeaux,
 May - September 1983, no. 23, illustrated on page 101
Oskar Kokoschka - Städteporträts, Hochschule für angewandte
 Kunst, Vienna, March - April 1986, page 134 and 136, illus-
 trated in color page 135
Oskar Kokoschka 1886-1980, Tate Gallery, London, June -
 August 1986, no. 68, illustrated in color, traveled to:
 Kunsthaus, Zurich, September - November 1986, no. 71,
 Solomon R. Guggenheim Museum, New York, December
 1986 - February 1987, no. 54, illustrated in color
Oskar Kokoschka, Kunstforum Länderbank, Vienna, March -
 June 1991, no. 47, illustrated in color
University of Arizona Art Museum, Tucson, April 1999 - June 2000

Literature:
Das Kunstblatt, Berlin, 1928, illustrated page 193 (supplement)
Georg Biermann, Oskar Kokoschka, Klinkhard & Biermann, Leipzig and Berlin, 1929, illustrated no. 30
Hans Heilmaier, Kokoschka, Crès, Paris 1929, no. 28 (supplement)
Wolfgang Born, Neue Bilder von Oskar Kokoschka, Deutsche Kunst und Dekoration, 1930, illustrated. after page 84
Emil Waldmann, La Peinture Allemande Contemporaine, Crès, Paris, 1930, illustrated no. 38
Der Wiener Kunstwanderer, Vienna, 1933, no. 10, illustrated page 6
Hans Platschek, Oskar Kokoschka, Ed. Poseidon, 1946, illustrated no. 31
Edith Hoffmann, Kokoschka: Life and Work, Faber & Faber, London 1947, page 187, illustrated as plate XLIX
Paul Westheim, Oskar Kokoschka: Landschaften II, Rascher, Zurich, 1948, page 9 - 10 and color illustration. no. 2
Leopold Zahn, Oskar Kokoschka: Das Kunstwerk, Baden-Baden, 1948, illustrated page 31
Hans M.Wingler, Oskar Kokoschka: Orbis Pictus, Mappe II. Verlag Galerie Welz, 1951, page 3, color illustration no. 1
The Phillips Collection. A museum of modern art and its sources, catalogue, Washington DC, 1952, page 57, illustrated 203
Hans M. Wingler, Oskar Kokoschka, Das Werk des Malers, Verlag Galerie Welz, 1956, no. 232, page 318
Bernard S. Myers, Malerei des Expressionismus, DuMont Schauburg, Cologne 1957, page 68
Hans M. Wingler, Kokoschka - Fibel, Verlag Galerie Welz, 1957, page 126, illustrated in color page 127
Karel B. Palkovský, Oskar Kokoschka, Prague, 1958, illustrated no. 32 and color illustration opposite page 32
Bernhard Borchert, Kokoschka, Safari-Verlag, Berlin, 1959, page 16, color illustration 7
Bernhard Bultmann, Oskar Kokoschka, Verlag Galerie Welz, London, 1959, pages 39-40 and 90, color illustration 23
Siegfried Wichmann, Realismus und Impressionismus in Deutschland, Verlag Schuler, Stuttgart, 1964, illustrated in color page 170
Werner Haftmann, Malerei im 20. Jahrhundert, Prestel, Munich, 1965, page 297, illustrated 741
Fritz Schmalenbach, Oskar Kokoschka, New York Graphic Society, 1967, illustrated in color page 66
Joseph P. Hodin, Oskar Kokoschka: Sein Leben, Seine Zeit, Kupferberg, Mainz & Berlin,1968, pages 276-277
Marjorie Phillips, Duncan Phillips and his collection, Little, Brown and Co., Boston, Toronto 1970, illustrated in color opposite page 231
Joseph P. Hodin, Oskar Kokoschka. Eine Psychographie, Europa-Verlag, Vienna, 1971, illustrated page 79
Pier C. Santini, Il Paesaggio nella pittura contemporanea, Electa Ed., Milan, 1971, illustrated page185
Raymond J. Sontag, A Broken Word 1919-1939, Harper & Row, New York, 1971, illustrated page 40
Kevin Grogan. A collection in the making. Works from the Phillips Collection. Chicago University Press, Chicago & London 1976, page 43, color illustrated Microfiche 3, E10

Olda Kokoschka & Heinz Spielmann, Kokoschka Briefe 2, Claassen, Dusseldorf 1985, pages 169-172
The Phillips Collection. A summary catalogue. Washington, 1985, no. 981, illustrated
Eleanor Green; essays by Robert Cafritz, Master paintings from the Phillips Collection. reprint Washington, DC, 1988, page 102, illustrated in color no. 103
Norbert Werner, Kokoschka, Leben und Werk in Daten und Bildern, Insel-Verlag, Frankfurt & Leipzig, 1991, page 64, illustrated page 65
Edwin Lachnit, Der Mensch hat zwei Augen, 1991, page 32, color illustration, catalogue no. 47
Richard Calvocoressi, Kokoschka. Paintings. Poligrafa, Barcelona, 1992, illustrated in color no. 58
Johann Winkler and Katharina Erling, Oskar Kokoschka, Die Gemälde, 1906-1929, Verlag Galerie Welz, Salzburg, 1995, no. 243, illustrated page 138

9. *Illustrated in color page 16*
Girl with Goose in Basket 1930
39.1 x 28.7 in / 99.4 x 73 cm
signed lower right: OK

Provenance:
Private Collection, Austria

Exhibited:
Klimt, Schiele, Kokoschka and Kubin, Galerie St. Etienne, New York, March-April 1961, no.36, illustrated on cover
Kokoschka, Arts Council, Tate Gallery, London, September-October 1962, no.113
Kokoschka, Kunstverein, Hamburg, December 1962, no.56, illustrated
Hommage to Kokoschka, Marlborough Fine Art, London, March - April 1966, no. 7, illustrated page 24
Oskar Kokoschka: An 80th Birthday Tribute, Marlborough-Gerson Gallery, New York 1966, no.42, illustrated page 61
Große Kunstausstellung, Haus der Kunst, Munich, 1975, no.100
Oskar Kokoschka zum 90. Geburtstag, Kunstsalon Wolfsberg, Zurich, February-March 1976, illustrated
Palais Thurn und Taxis Künstlerhaus, Bregenz, July - September 1976, no.18, illustrated in color plate IX
Oskar Kokoschka, Museum of Modern Art, Kamakura, March - April 1978; National Museum of Modern Art, Kyoto, Japan, April - May 1978, no.10, illustrated in color
Oskar Kokoschka, Memorial Exhibition, Marlborough Gallery Inc. New York, May - June 1981; Marlborough Fine Art, London, June - July 1981, no.27, illustrated in color page 50
Oskar Kokoschka 1886-1980, Palazzo Venezia, Rome, November 1981 - February 1982, no.129, illustrated page 58
Oskar Kokoschka 1886-1980, Galerie des Beaux-Arts, Bordeaux, May - September 1983, no. 26, illustrated page 104
Europalia '87 Österreich, Museum voor Schoone Kunsten, Ghent, September - November 1987; Salle Saint-Georges, Liège, Nov. - Dec. 1987, no.31, page 212

Oskar Kokoschka 1886-1980, Museu Picasso, Barcelona,
 February - April 1988, no.36, illustrated in color page 70
Oskar Kokoschka, Kunstforum Länderbank, Vienna, March -
 June 1991, no. 56, illustrated in color
*Oskar Kokoschka: Emigrantenleben, Prag und London 1934-
 1953,* Kunsthalle, Bielefeld, November 1994 - February
 1995, no.1, illustrated in color page 48

Literature:
To be included in the forthcoming revised complete catalogue
of the oil paintings of Oskar Kokoschka (Volume II) by
Johann Winkler and Katharina Erling, no. 262.

10. *Illustrated in color page 17*
Still Life with Summer Flowers and Ferns 1931
27.5 x 36.7 in / 69.8 x 93.2 cm
signed lower left: OK

Provenance:
Fritz Wolff, Vienna / New York
Annie Knize, New York
Galerie Ehrenzweig, New York
Mr and Mrs John D. Rockefeller III
Private Collection, Switzerland

Exhibited:
*Ausstellung von Erwerbungen und Widmungen zu Gunsten der
 öffentlichen Sammlungen des Vereines der Museumsfreunde in
 Wien 1912-1936 sowie von Kunstwerken aus Privatbesitz,*
 Secession, Vienna, September - October 1936, no. 175
Oskar Kokoschka, Österreichisches Museum für Kunst und
 Industrie, Vienna, May-June 1937, no. 19
Oskar Kokoschka, The Bayer Gallery, New York, January -
 February, 1959, no. 14
Of Art and Nature, Guild Hall, East Hampton, New York, 1961
Masterpieces in Bloom, Wildenstein & Co., New York, 1973

Literature:
Edith Hoffman, <u>Kokoschka: Life and Work,</u> London 1947,
 no. 243
Hans Maria Wingler, <u>Oskar Kokoschka,</u> Verlag Galerie Welz,
 Salzburg 1956, no. 255, illustrated no. 321

To be included in the forthcoming revised complete catalogue
of the oil paintings of Oskar Kokoschka (Volume II) by
Johann Winkler and Katharina Erling, no. 277

11. *Illustrated in color page 18*
Girl with Flowers 1932
28.7 x 23.6 in / 73 x 60 cm
signed lower left: OK

Provenance:
Otto Nierenstein, Neue Galerie, Vienna
Meister Collection, Lucerne, later Basel
Galerie Beyeler, Basel
Galerie Aenne Abels, Cologne
Jerome Green, New York
Private Collection, Switzerland

Exhibited:
Oskar Kokoschka, Kunsthalle, Basel, 1947, no. 140
Oskar Kokoschka, Kunsthaus, Zurich, 1947, no. 19
Bilder des 20. Jahrhunderts, Galerie Beyeler, Basel, April-May
 1952, no. 20
Expressionisten, Galerie Beyeler, Basel, 1955, illustrated page 30
Die Frau in der Kunst, 50th Anniversary of Galerie Neupert,
 Zurich, January-March 1956, no. 124
Expressionisten, Galerie Aenne Abels, Cologne, May-June
 1956, no. 8
Oskar Kokoschka, Haus der Kunst, Munich; Künstlerhaus,
 Vienna, 1958, no. 50
Kokoschka, Tate Gallery, London, September-October 1962,
 no. 70
Homage to Kokoschka, Marlborough Fine Art, London, March-
 April 1966, no. 6, illustrated page 23
Oskar Kokoschka: An 80th Birthday Tribute, Marlborough-
 Gerson Gallery, New York, 1966, no. 26, illustrated
International Expressionism (Part 1), Marlborough-Gerson
 Gallery, New York, 1968, no. 28, illustrated
Oskar Kokoschka, Fundacion Juan March, Madrid, May-July
 1975, no. 4, illustrated page 13, no. 12, in color
Oskar Kokoschka, Museum of Modern Art, Kamakura, March-
 April 1978; National Museum of Modern Art, Kyoto, Japan,
 April-May 1978, no. 5 illustrated
Oskar Kokoschka: Memorial Exhibition, Marlborough Gallery
 Inc., New York, May-June 1981; Marlborough Fine Art,
 London, June-July 1981, no. 18, illustrated page 41 in color
Oskar Kokoschka 1886-1980, Palazzo Venezia, Rome, November
 1981-February 1982, page 129, illustrated page 52
Oskar Kokoschka 1886-1980, Tate Gallery, London, June-
 August 1986; Kunsthaus, Zurich, September-November
 1986, no. 52, illustrated in color; Soloman R. Guggenheim
 Museum, New York, December 1986-February 1987, no. 51,
 illustrated in color
Europalia '87 Österreich, Museum voor Schone Kunsten,
 Ghent, September-November 1987; Salle Saint-Georges,
 Liège, November -December 1987, no. 20, page 208, illus-
 trated page 94 in color
Oskar Kokoschka 1886-1980, Museu Picasso, Barcelona,
 February-April 1988, no. 21, illustrated in color page 55
Oskar Kokoschka, Kunstforum Länderbank, Vienna, March -
 June 1991, no. 57, illustrated in color

Literature:
Hans Maria Wingler, <u>Oskar Kokoschka -The Work of the Painter,</u>
 Galerie Verlag Welz, Salzburg, 1958, no. 159, illustrated page 311

To be included in the forthcoming revised complete catalogue
of the oil paintings of Oskar Kokoschka (Volume II) by
Johann Winkler and Katharina Erling, no. 282

12. *Illustrated in color page 19*
Vienna, View from Liebhartstal I (View from the Artist's
 House) 1933
21 x 29 in / 53.3 x 73.6 cm
signed lower left: OK

Collection: Grand Rapids Art Museum, Grand Rapids, Michigan

Provenance:
Otto Nierenstein, Neue Galerie, Vienna
Otto Kallir-Nierenstein, Galerie St. Etienne, New York
Marguerite T. Inslee, Grand Rapids, Michigan
Grand Rapids Art Museum, Museum Purchase 1955.1.4,
 Grand Rapids, Michigan

Exhibited:
Oskar Kokoschka, Galerie Feigl, Prague, 1933-34, no. 13
Oskar Kokoschka, Galerie St. Etienne, Paris, April - May 1939
Oskar Kokoschka, Galerie St. Etienne; Buchholz Gallery, New
 York, January - February 1940, no. 3
Oskar Kokoschka, The Arts Club, Chicago, January 1941, no. 11
Paintings, watercolors, drawings and lithographs by Oskar
 Kokoschka, City Art Museum, St. Louis, October 1942, no. 12
Oskar Kokoschka, Galerie St. Etienne, New York, April 1949
Paintings by Oskar Kokoschka, Museum of Art, Santa Barbara,
 February - March 1954, no. 18
Oskar Kokoschka: Memorial Exhibition, Marlborough Gallery
 Inc., New York, May-June 1981; Marlborough Fine Art,
 London, June-July 1981, no. 29, illustrated page 52
Richard Gerstl - Oskar Kokoschka, Galerie St. Etienne, New
 York, March - May 1992, no. 73

Literature:
To be included in the forthcoming revised complete catalogue
of the oil paintings of Oskar Kokoschka (Volume II) by
Johann Winkler and Katharina Erling, no. 298

13. *Illustrated in color page 20*
Prague, View from the Banks of the River Moldau
to the Kleinseite and the Laurenziberg II 1937
21.6 x 29.5 in / 55 x 74.9 cm
signed lower left: OK

Provenance:
Galerie Würthle, Vienna
Emmanuel Schlesinger, Vienna
Private Collection, Switzerland

Exhibited:
Oskar Kokoschka, Fundacion Juan March, Madrid, May-July
 1975, no. 10, illustrated page 47
Kokoschka; Cityscapes and Landscapes. A 90th Birthday Tribute,
 Marlborough Fine Art, London, 1976, no. 9, illustrated in color
Oskar Kokoschka, Museum of Modern Art, Kamakura, March-
 April 1978; National Museum of Modern Art, Kyoto, Japan,
 April - May 1978, no. 14 illustrated
Oskar Kokoschka: Memorial Exhibition, Marlborough Gallery,
 New York, May - June 1981; Marlborough Fine Art,
 London, June - July 1981, no.36, illustrated in color page 59
Oskar Kokschka 1886-1980, Museum des 20. Jahrhunderts,
 Vienna, March-April, 1982, no. 91
Oskar Kokoschka 1886-1980, Palazzo Venezia, Rome, November
 1981 - February 1982, page 129, illustrated page 68
Oskar Kokschka 1886-1980, Galerie des Beaux-Arts, Bordeaux,
 May-September 1983, no. 36, illustrated page 116
Oskar Kokoschka - Städteporträts, Hochschule für Angewandte
 Kunst, Vienna, March-April 1986, page 74, illustrated page
 75 in color
Masters of the 19th and 20th Centuries, Marlborough Gallery,
 New York, November - December 1986, no. 21, illustrated
 in color
Europalia '87 Österreich, Museum voor Schone Kunsten,
 Ghent, 17 Sept. - 8 Nov. 1987; Salle Saint-Georges, Liège,
 November - December 1987, no. 39, page 214, illustrated in
 color page 111
Oskar Kokoschka 1886-1980, Museu Picasso, Barcelona,
 February - April 1988, no. 46, illustrated in color page 79

Literature:
To be included in the forthcoming revised complete catalogue
of the oil paintings of Oskar Kokoschka (Volume II) by
Johann Winkler and Katharina Erling, no. 330

14. *Illustrated in color page 21*
Kathleen, Countess of Drogheda 1944-47
oil on canvas
40.1 x 30.3 in / 101.8 x 77 cm
signed lower left: OK

Collection: Private Collection, courtesy of Galerie Beyeler, Basel

Provenance:
Private Collection, London
Private Collection

Exhibited:
Oskar Kokoschka, Kunsthalle, Basel, March - April 1947, no. 76, illustrated
Oskar Kokoschka, Kunsthaus, Zurich, July - August 1947, no. 65
Oskar Kokoschka: A Retrospective Exhibition, Institute of Contemporary Art, Boston, October - November 1948, no. 58, illustrated. Travelling to: Phillips Memorial Gallery, Washington, DC, December 1948 - January 1949; City Art Museum, St. Louis, February - March 1949; M. H. de Young Memorial Museum, San Francisco, April - May 1949; Delaware Art Center, Wilmington, June - July 1949; Museum of Modern Art, New York, July - October 1949
Oskar Kokoschka, Haus der Kunst, Munich, March - May 1958, no. 119, illustrated in color page 81
Der späte Kokoschka, Haus Salve Hospes, Braunschweig, January - February 1960, no. 15
Oskar Kokoschka in England and Scotland, Marlborough Fine Art, London, November - December 1960, no. 21
Oskar Kokoschka: Bildnisse von 1907-1970, Haus der Kunst, Munich, July - September 1971, no. 37, illustrated in color
Oskar Kokoschka: Memorial Exhibition, Marlborough Gallery, New York, May - June 1981; Marlborough Fine Art, London, June - July 1981, no. 44, illustrated page 67
Hommage à Oskar Kokoschka 1886-1980, Musée Jenisch, Vevey, April - June 1984, no. 24
Oskar Kokoschka 1886-1980, Tate Gallery, London, June - August 1986, no.98, illustrated in color
Oskar Kokoschka 1886-1980, Kunsthaus, Zurich, September - November 1986, no. 100, illustrated in color
Oskar Kokoschka 1886-1980, Solomon R. Guggenheim Museum, New York, December 1986 - February 1987, no. 76, illustrated in color
L'éternel féminin, Galerie Beyeler, Basel, November 1989 - January 1990, no. 30, illustrated in color
Oskar Kokoschka, Emigrantenleben, Prag und London 1934-1953, Kunsthalle, Bielefeld, November 1994 -February 1995, catalogue no. 95, illustrated in color page 209
The Exhibition from Swiss Private Collections, coordinated by Ernst Beyeler, Basel, Hokkaido Museum of Modern Art, Sapporo, May-June 1996; Huis ten Bosch Museum of Art, Nagasaki, June-August 1996; Kyoto Municipal Museum of Art, Tokyo, October -November 1996, catalogue no. 40, page 96, illustrated in color page 97

Literature:
Edith Hoffmann, <u>Kokoschka: Life and Work,</u> London, 1947, no. 307, page 337, illustrated in an earlier state, plate LXXXII
Hans Maria Wingler, <u>Oskar Kokoschka, The Work of the Painter,</u> Verlag Galerie Welz, Salzburg, 1958, no. 336, page 330, illustrated plate 109
Bernhard Bultmann, <u>Oskar Kokoschka,</u> Thames & Hudson, London, 1961, color plate 44
Joseph P. Hodin, <u>Oskar Kokoschka: The Artist and his Time,</u> New York Graphic Society, Greenwich, CT, 1966, illustrated no. 49
Frank Whitford, <u>Oskar Kokoschka: A Life,</u> Weidenfeld & Nicholson, London, 1986, page 182
Richard Calvocoressi, <u>Kokoschka,</u> Bongers, Recklinghausen, 1992, color illustration no. 85

To be included in the forthcoming revised complete catalogue of the oil paintings of Oskar Kokoschka (Volume II) by Johann Winkler and Katharina Erling, no. 359

15. *Illustrated on page 22*
Two Girls with Pigeon, 1953-64
oil on canvas
35.5 x 25.6 in / 90 x 65 cm
signed lower left: OK
inscribed on the reverse: OK 55-64 Villeneuve

Collection: Private Collection, Switzerland

Provenance:
The Artist
Private Collection, Switzerland

Exhibited:
Große Kunstausstellung, Haus der Kunst, Munich 1957, catalogue no. 976
Oskar Kokoschka, Künstlerhaus, Vienna, May-July, 1958, catalogue no. 157
Große Kunstausstellung, Haus der Kunst, Munich 1965, catalogue no. 194, illustrated in color page 34
Oskar Kokoschka: An 80th Birthday Tribute, Marlborough-Gerson Gallery, New York, October-November 1966, catalogue no. 63, illustrated in color page 85
Oskar Kokoschka: Paintings and Watercolors since 1953, B.A.T. Haus und Kunsthaus, Hamburg, February - May 1975, catalogue no. 12
Oskar Kokoschka, Fundacion Juan March, Madrid, May - July 1975, catalogue no. 12, illustrated in color no. 24 on page 25
Oskar Kokoschka, Museum of Modern Art, Kamakura, National Museum of Modern Art, Kyoto, 1978, catalogue no. 23, illustrated
Oskar Kokoschka: Memorial Exhibition, Marlborough-Gerson Gallery, New York, May - June 1981, Marlborough Fine Art, London, June - July 1981, catalogue no. 49, illustrated page 72

Oskar Kokoschka 1886-1980, Galerie des Beaux-Arts, Bordeaux, May - September 1983, catalogue no. 52, illustrated page 136

Hommage à Oskar Kokoschka 1886-1980, Musée Jenisch, Vevey, April - June 1984, catalogue no. 38, illustrated in color

Masters of the 19th and 20th Centuries, Marlborough Gallery, New York, November - December 1986, catalogue no. 22, illustrated in color

Oskar Kokoschka-The Late Work 1953-1980, Marlborough Fine Art, London, June - July 1990, catalogue no. 11, illustrated in color

Oskar Kokoschka, Kunstforum Länderbank, Vienna, March - June 1991, catalogue no. 80, illustrated in color

Literature:
Hans Maria Wingler, Oskar Kokoschka - The Work of the Painter, Verlag Galerie Welz, Salzburg, catalogue no. 392, illustrated page 335

Josef P. Hodin, Kokoschka und Hellas, Vienna 1975, page 58

Oskar Kokoschka, Mizue, *Monthly Review of the Fine Arts,* Tokyo, 5 May 1978, no. 878, illustrated in color page 16

To be included in the forthcoming revised complete catalogue of the oil paintings of Oskar Kokoschka (Volume II) by Johann Winkler and Katharina Erling, no. 456

16. *Illustrated in color page 23*
London, Chelsea Reach 1957
29.8 x 39.9 in / 75.7 x 101.3 cm
signed lower left: OK

Provenance:
The Artist
Marlborough Fine Art Ltd., London
Sir Basil Goulding, Dublin
Private Collection, London

Exhibited:
Oskar Kokoschka, Haus der Kunst, Munich, 1958, no. 149a

Oskar Kokoschka, Künstlerhaus, Vienna, 1958

Oskar Kokoschka, Gemeentemuseum, The Hague, 1958

Oskar Kokoschka in England and Scotland, Marlborough Fine Art, London, November - December 1960, no. 28

Kokoschka Cityscapes and Landscapes. A 90th Birthday Tribute, Marlborough Fine Art, London, 1977, no. 16, illustrated

London and the Thames; Paintings of Three Centuries, Somerset House, London 1977, no. 112, illustrated

Oskar Kokoschka (1886 - 1980) Memorial Exhibition, Marlborough Gallery, New York, May - June 1981; Marlborough Fine Art, London, June - July 1981, no. 50, illustrated

Oskar Kokoschka 1886 - 1980, Galerie des Beaux-Arts, Bordeaux, May - September 1983, no. 55, illustrated

Oskar Kokoschka Städteporträts, Hochschule für Angewandte Kunst, Vienna, March - April, 1986, page 94, illustrated in color page 95

Oskar Kokoschka (1886 - 1980), Kunsthaus, Zurich, September - November 1986, no. 110, illustrated in color

Europalia '87 Österreich, Museum voor schone Kunsten, Ghent, September - November 1987; Salle Saint-Georges, Liège, November - December 1987, no. 51, page 218, illustrated in color page 122

Oskar Kokoschka (1886 - 1980), Museu Picasso, Barcelona, February - April 1988, no. 58, illustrated in color page 91

Perspective of 20th Century Paintings, Nagoya City Art Museum, April - June 1988, no. 11, page 41, illustrated in color

Oskar Kokoschka: The Late Work 1953 - 1980, Marlborough Fine Art, London, June - July 1990, no. 2, illustrated in color

Literature:
Jan Tomeš, Oskar Kokoschka: London Views - British Landscapes, London 1972, illustrated in color page 65.

To be included in the forthcoming revised complete catalogue of the oil paintings of Oskar Kokoschka (Volume II) by Johann Winkler and Katharina Erling, no. 421

17. *Illustrated in color page 24*
Still Life with Flowers 1959
35 x 27.5 in / 88.9 x 69.9 cm
signed lower right: OK

Provenance:
The Artist
Marlborough Fine Art Ltd., London
Private Collection, Germany

Exhibited:
Große Kunstausstellung, Haus der Kunst, Munich, June - Oct. 1961, no. 190

Der Gegenstand in der österreichischen Malerei und Plastik, Secession, Vienna, October - November 1961, no.22, illustrated

Oskar Kokoschka zum 85. Geburstag, Österreichische Galerie, Vienna, April - June 1971, no. 73

Oskar Kokoschka 1886-1980, Museum des 20. Jahrhunderts, Vienna, March - April 1982, no. 110

Oskar Kokoschka: The Late Work 1953-1980, Marlborough Fine Art, London, June-July 1990, no. 6, illustrated in color

Literature:
To be included in the forthcoming revised complete catalogue of the oil paintings of Oskar Kokoschka (Volume II) by Johann Winkler and Katharina Erling, no. 434

18. *Illustrated in color page 25*
London, The Thames from Vickers Tower, Millbank 1962
36 x 50 in / 91.4 x 127 cm
signed lower left: OK

Collection: Private Collection, New York

Provenance:
The Artist
Marlborough Gallery, New York
Private Collection, New York

Exhibited:
Oskar Kokoschka, Tate Gallery, London, September -
 November 1962, no. 160, illustrated in color
The 1964 Pittsburgh International, Carnegie Institute,
 Pittsburgh, October 1964 - January 1965, no. 250
Oskar Kokoschka, Marlborough-Gerson Gallery, New York,
 October - November 1966, no. 60, illustrated page 80

Literature:
Anthony Bosman, Oskar Kokoschka, Barnes & Noble, New
 York, 1964, illustrated in color page 72
Jan Tomeš, Oskar Kokoschka: London Views - British
 Landscapes, Thames & Hudson, London, 1972, page 75,
 76, 79, color plate page 77

To be included in the forthcoming revised complete catalogue
of the oil paintings of Oskar Kokoschka (Volume II) by
Johann Winkler, and Katharina Erling, no. 447

19. *Illustrated in color page 26*
London, Tower Bridge II 1963
35. 7 x 49.7 in / 90.7 x 126.2 cm
signed lower right: OK

Provenance:
The Artist
Marlborough Fine Art Ltd., London
Private Collection, Germany

Exhibited:
Oskar Kokoschka zum 85. Geburtstag, Österreichische Galerie,
 Vienna, April - June 1971, illustrated in color no. 66
Oskar Kokoschka 1886-1980, Galerie des Beaux Arts,
 Bordeaux, May - September 1983, no. 58, illustrated page
 142, illustrated in color page 60
Oskar Kokoschka: Städteporträts, Hochschule für Angewandte
 Kunst, Vienna, March - April 1986, page 102, illustrated in
 color page 103
Oskar Kokoschka: The Late Work 1953-1980, Marlborough Fine
 Art, London, June - July 1990, no. 10, illustrated in color
Oskar Kokoschka, Kunstforum Länderbank, Vienna, March -
 June 1991, no. 79, illustrated in color

Literature:
S. Rosu, Kokoschka, Bucharest 1971, illustrated in color page 51
Fritz Schmalenbach, Oskar Kokoschka, Königstein im Taunus
 1967, illustrated page 29
Jan Tomeš, Oskar Kokoschka: London Views - British
 Landscapes, London 1972, illustrated page 81

To be included in the forthcoming revised complete catalogue
of the oil paintings of Oskar Kokoschka (Volume II) by
Johann Winkler and Katharina Erling, no. 453

20. *Illustrated in color page 27*
Still Life with Cat 1965
31.7 x 25.5 in / 80.5 x 64.8 cm
signed lower right: OK

Collection: Private Collection, New York

Provenance:
The Artist
Marlborough Fine Art Ltd., London
Private Collection, Washington, DC
Private Collection, New York

Exhibited:
Große Kunstausstellung München 1965, Haus der Kunst,
 Munich, June - October 1965, no. 193
Oskar Kokoschka, Marlborough-Gerson Gallery, New York,
 October - November 1966, no. 65, illustrated page 82
Oskar Kokoschka, Kunsthaus, Zurich, June - July 1966, ex-catalogue

Literature:
To be included in the forthcoming revised complete catalogue
of the oil paintings of Oskar Kokoschka (Volume II) by
Johann Winkler and Katharina Erling, no. 460

21. *Illustrated in color page 28*
New York, Manhattan with the Empire State Building
1966
40 x 54 in / 101.6 x 137.2 cm

Collection: Private Collection

Provenance:
The Artist
Marlborough Gallery, New York
Mr and Mrs John Mosler, New York
Private Collection, New York
Private Collection

Exhibited:
Kokoschka, Marlborough Fine Art, London, July-August 1967,
 no. 2, illustrated in color
Oskar Kokoschka 1886-1980 Memorial Exhibition, May- June

1981, Marlborough Gallery Inc., New York, June - July 1981, no. 56, illustrated in color page 79
Oskar Kokoschka 1886-1980, Tate Gallery, London, June - August 1986, no. 109, illustrated in color
Oskar Kokoschka 1886-1980, Solomon R. Guggenheim Museum, New York, December 1986 - February1987, no. 86, illustrated in color

Literature:
Fritz Schmalenbach, Oskar Kokoschka, New York Graphic Society, Greenwich, CT, 1967, illustrated in color page 80
Giuseppe Gatt, Oskar Kokoschka, Lucerne, 1972, illustrated page 40
Richard Calvocoressi, Kokoschka, Recklinghausen, Bongers, 1992, color illustrated no. 99

To be included in the forthcoming revised complete catalogue of the oil paintings of Oskar Kokoschka (Volume II) by Johann Winkler and Katharina Erling, no. 465

22. *Illustrated in color page 29*
Gstaad 1967-68
35.5 x 43.2 in / 90.2 x 110 cm
signed lower right: OK

Provenance:
The Artist
Marlborough Fine Art Ltd., London
Morton D. May, St. Louis
Private Collection, Switzerland

Exhibited:
Recent Acquisitions, Marlborough Fine Art, London 1968, no. 21, illustrated
The Morton D. May Collection of 20th Century German Masters, Marlborough -Gerson Gallery, New York, City Art Museum of St. Louis, 1970, no. 93, illustrated
Oskar Kokoschka, Fundacion Juan March, Madrid, May - July 1975, no. 33
Kokoschka - Cityscapes and Landscapes, A 90th Birthday Tribute, Marlborough Fine Art, London, 1976, catalogue no. 18, illustrated in color
Oscar Kokoschka Memorial Exhibition, Marlborough Gallery Inc. New York, May - June 1981; Marlborough Fine Art, London June - July 1981, page 22, no. 58, illustrated in color page 81
Oskar Kokoschka, The Late Work 1953 - 1980, Marlborough Fine Art, London, June - July 1990, catalogue number 17, illustrated in color

Literature:
To be included in the forthcoming revised complete catalogue of the oil paintings of Oskar Kokoschka (Volume II) by Johann Winkler and Katharina Erling, no. 468

Works on Paper

23. *Illustrated in black and white page 30*
Sitting Woman in Profile 1910
ink and charcoal
18.8 x 14.6 in / 47.7 x 37.1 cm

Collection: Private Collection, USA

Provenance:
Lotte Mandl, Vienna
Private Collection, USA

24. *Illustrated in black and white page 31*
Lotte Mandl as a Young Girl 1916
charcoal
25.5 x 17.7 in / 64.8 x 45 cm

Collection: Private Collection, USA

Provenance:
Lotte Mandl, Vienna
Private Collection, USA

25. *Illustrated in color page 32*
Reclining Girl in a Red Dress 1921
watercolor
27.8 x 20.6 in / 70.6 x 52.3 cm

Collection: Private Collection, USA

Provenance:
Annie Knize, New York
Private Collection, USA

26. *Illustrated in color page 33*
Woman with Right Arm on Hip 1921
watercolor
27.7 x 20.6 in / 70.4 x 52.3 cm

Collection: Private Collection, USA

Provenance:
Annie Knize, New York
Private Collection, USA

27. *Examples illustrated in black and white page 34*
Group of 12 drawings of *Lotte Mandl* 1923-24
pencil on graph paper
each work approximately: 11.4 x 9 in / 29 x 22.9 cm

Collection: Private Collection, USA

Provenance:
Lotte Mandl, Vienna
Private Collection, USA

28. *Illustrated in black and white page 35*
Woman in Red Turban 1924
watercolor
27.3 x 20.2 in / 69.3 x 51.3 cm

Collection: Private Collection, USA

Provenance:
Lotte Mandl, Vienna
Private Collection, USA

29. *Illustrated in color page 36*
Trudl (Woman in Turban) 1931
watercolor
22 x 17 in / 55.9 x 43.2 cm

Collection: Private Collection, USA

Provenance:
Annie Knize, New York
Private Collection, USA

30. *Illustrated in color page 37*
Woodland Scene with Nudes 1938
watercolor
16 x 19.8 in / 40.6 x 50.3 cm

Collection: Private Collection, USA

Provenance:
Annie Knize, New York
Private Collection, USA

31. *Illustrated in color page 37*
Lupin 1939
watercolor
18.9 x 24.8 in / 48 x 63 cm
signed and dated lower right: O. Kokoschka 1939

32. *Illustrated in color page 38*
Mixed Flowers in a Chinese Vase 1940
watercolor
17.7 x 22.4 in / 45 x 56.9 cm

33. *Illustrated in color page 38*
Yellow and Blue Iris 1960
watercolor
24.9 x 18.7 in / 63.2 x 47.5 cm
signed and dated lower right: O. Kokoschka 1960

34. *Illustrated in color page 39*
Yellow Climbing Roses 1961
watercolor
26.1 x 18.7 in / 66.3 x 47.5 cm
signed and dated lower right: O. Kokoschka 61

35. *Illustrated in black and white page 40*
Greek Female Head 1962
Black conté crayon
24.4 x 19.5 in / 62 x 49.5 cm
signed and dated lower right: O. Kokoschka 1962

36. *Illustrated in color page 40*
Still Life 1965
watercolor
18.9 x 25.7 in / 48 x 65.3 cm
signed and dated lower right, O. Kokoschka

37. *Illustrated in color page 41*
Recto: **Three Tortoises** 1968
watercolor
25.7 x 19.7 in / 65.3 x 50.1 cm
signed and dated lower right: O. Kokoschka 6.68
Verso: **Tortoise**
watercolor

38. *Illustrated in color page 42*
Summer Flowers with Delphinium c. 1970-72
watercolor
25.7 x 20 in / 65.3 x 50.8 cm

39. *Illustrated in color page 39*
Summer Flowers with Rose c. 1970-72
watercolor
27.4 x 20.5 in / 69.5 x 52.1 cm

40. *Illustrated in color page 43*
Olda 1970
watercolor
25.5 x 19.6 in / 64.8 x 49.8 cm
signed and dated lower right: O. Kokoschka 6.1.70

41. *Illustrated in color page 44*
Woodpecker 1971
watercolor
25.7 x 18.8 in / 65.3 x 47.7 cm
signed and dated lower right: O. Kokoschka 1971

42. *Illustrated in color page 45*
Mixed Flowers 1972
watercolor
26 x 18.9 in / 66 x 48 cm

Chronology

1886
Born 1 March in Pöchlarn, Austria, a small town on the river Danube, of Czech and Austrian parentage. Childhood and youth spent mainly in Vienna.

1904-09
Student at the Kunstgewerbeschule, Vienna. Receives a thorough training in drawing and experiments in oils on his own. Works for the "Wiener Werkstätte" on a freelance basis.

1908
Publication of Die träumenden Knaben. Takes part in an exhibition for the first time (*Kunstschau,* Vienna).

1909-10
The period of the "psychological" portraits. Has two plays performed at the *Internationale Kunstschau* 1909 in Vienna. Visits Switzerland and Berlin. Exhibition at Paul Cassirer's gallery, Berlin. Contributes to the Berlin periodical *Der Sturm.*

1911-14
Mainly in Vienna. Begins a passionate romance with Alma Mahler in 1912. Dramen und Bilder published in 1913. Visits Italy together with Alma. Paints *Die Windsbraut* ("The Tempest"), now in the Kunstmuseum, Basel.

1914
Lithographs for the "Bach-Kantate"- *O Ewigkeit Du Donnerwort (Eternity thou Fearful Word).*

1915-16
Called up for service on the Eastern front; badly wounded; convalesces. In 1916 official war artist on the Isonzo front in Italy; goes to Berlin after demobilization and moves to Dresden towards the end of 1916.

1917
Group portraits, drawings and plays. Visits Stockholm for the exhibition *Modern Austrian Art* and the International Peace Congress and seeks treatment for the after-effects of his injuries.

1918
Publication of Paul Westheim's Oskar Kokoschka, the first comprehensive monograph.

1919
Appointed to the Dresden Academy, where he teaches until 1923. Cassirer publishes his Vier Dramen (Murderer Hope of Women, Job, The Burning Bush and Orpheus and Eurydice).

1920
Travels to Vienna and stays there for seven months.

1921-23
Prolific period of creativity in Dresden: Paintings include views of the Elbe and biblical scenes. Watercolors and portrait lithographs. Leaves Dresden in August 1923 for Switzerland. The Dresden Academy grants a two-year sabbatical which is prolonged in 1925. In 1927, however, the contract is cancelled.

1924-31
Extensive travels. Paints mainly views of cities and landscapes.

1924
Travels to Vienna, Italy (Venice, Florence), Paris.

1925
Travels to south of France, the Riviera, Spain, Portugal, Paris, London, Amsterdam.

1926
Travels to Berlin, London, Paris, Vienna.

1927
Travels to Berlin, Venice, Courmayeur, Chamonix, Annecy, Lyon, Paris.

1928
Visits North Africa (Tunis, Sahara Desert, Algeria): Outstanding portrait of the Marabout of Temacine. Returns to Europe via Seville, Madrid and Barcelona. Later in London for the first presentation of his work in Britain at the Leicester Galleries. Travels to Ireland.

1929
Travels to Egypt, Jerusalem, Istanbul. August and September in Scotland. Winter in Paris.

1930
Elected a member of the Prussian Academy of Arts (Berlin). Travels to North Africa again, visiting Tunis, the island of Djerba and Kairouan. Summer in Italy (Rome, Anticoli). Back to Paris via Annecy.

1931
Despite the success of major retrospectives in Mannheim and Paris his contract with Cassirer in Berlin is dissolved because of the difficult economic situation. Returns from Paris to Vienna to stay with his parents for seven months.

1932-33
Mainly in Paris. Summer 1933 in Rapallo. Increasing financial difficulties. In autumn moves into his mother's house in Vienna. Growing concern about the political development in Germany and Austria.

1934-38
Leaves Vienna after his mother's death in July 1934 for Prague. Paints 16 Prague panoramas and portrays the Czech president T. G. Masaryk. Vienna shows the first representative retrospective in 1937. In Germany all his works in public col-

lections are confiscated in the course of the Nazi attacks on "degenerate art". Paints *Self-portrait of a "degenerate artist"*.

1938
Moves to London with Olda Palkovská, who will become his wife in 1941.

1939-40
Exhibition in Paris (1939). From August 1939 to July 1940 in Polperro (Cornwall). Back to London. Supports the Free German League of Culture (F.D.B.K.) Begins a series of political allegories and studies of nature (watercolor).

1941
Exhibitions at the Arts Club, Chicago, and the Buchholz Gallery, New York.

1942-46
London, with several summers spent in Scotland. Begins to use colored pencils for sketchbooks which he regards as diaries made up of drawings.

1947
Becomes a British subject. Visits Switzerland. Paintings of mountain scenery. Big exhibitions in Basel and Zurich. Publication of Edith Hoffmann's Kokoschka: Life and Work.

1948
Goes to Venice for the Biennale with a special presentation of his paintings. September to December in Florence: Paintings and numerous sketches. Travelling exhibition in the United States, lasting a year.

1949
Visits Vienna and Rome. First stay in the United States. Boston (Lectures at Tanglewood Summer School) and Minneapolis.

1950
Spring in London: Triptych *The Prometheus Saga*. Exhibition in Munich, travelling to Hamburg, Mannheim and Berlin.

1952
November to December in Minneapolis, lecturing at the Minneapolis School of Art.

1953
Foundation of the International Summer School for the Visual Arts in Salzburg. Kokoschka takes the main class, his "Schule des Sehens" (School of Seeing), and delivers this annual summer course regularly until 1963. In September Oskar and Olda Kokoschka move into their newly built house at Villeneuve, directly above Lake Geneva.

1954
Paints the triptych *Thermopylae* in Villeneuve. Visits London and paints two new Thames riverscapes.

1955
Travels to Austria. Designs settings for *The Magic Flute* which is produced at the Salzburg Festival, conducted by Georg Solti. Exhibition at the Vienna Secession.

1956
Internationally honoured on the occasion of his seventieth birthday. Awarded the Order of Merit by Theodor Heuss, president of the Federal Republic of Germany. Publication of his collected writings, Schriften 1907-1955, of a selection of his stories, Spur im Treibsand (published in English in 1962 as A Sea Ringed with Visions). Hans M. Wingler presents the first catalogue raisonné of Kokoschka's paintings and edits Oskar Kokoschka: ein Lebensbild in zeitgenössischen Dokumenten. Exhibitions in Prague and Salzburg. Travels to Greece, Vienna, Amsterdam and Cologne. September to October: School of Seeing in Sion.

1957
Visits to London, Salzburg, Florence and the United States (Minneapolis).

1958
Returns to Villeneuve at the end of January via New York. Major retrospective at the Haus der Kunst in Munich and at the Künstlerhaus in Vienna. Exhibition in The Hague. Travels from Salzburg to Lübeck and Hamburg.

1959
South Germany, Sicily. Autumn in London. Made Commander of the British Empire.

1960
Rome, Vienna (stage designs for the Burgtheater), Stuttgart, Copenhagen (exhibition on the occasion of being awarded the International Erasmus Prize together with Marc Chagall) and London (exhibition *Kokoschka in England and Scotland* at Marlborough Fine Art, London). Honorary Doctorate from Oxford University.

1961
Paris, Vienna (stage designs), Hamburg and Bremen. Latter part of the year in Greece, making numerous sketches and drawings which serve as the originals for the lithographic portfolio *Bekenntnis zu Hellas (Homage to Hellas)*.

1962
Stays in Hamburg and paints *Storm Tide in Hamburg* under the impact of the flooded city; Vienna (set and costume designs for the production of Ferdinand Raimund's play *The Captive Imagination* at the Burgtheater); London: *View of the Thames from the Vickers Tower, Millbank*. Autumn in London again for the opening of his major retrospective at the Tate Gallery.

1963
Works on lithograph series *King Lear* and *Apulian Journey*.

Stage designs for Verdi's *Ballo in Maschera* at Maggio Musicale Fiorentino. Last summer course in Salzburg. Autumn in London to complete the *View of the Thames with Tower Bridge*. Receives the American Academy Award honorary doctorate.

1964
Spring in London (stage and costume designs for a new production of *The Magic Flute* at Covent Garden; completed the following year in Villeneuve and finally used for a production at the Grand Théatre in Geneva); afterwards in Freiburg/Breisgau to paint a view of the southern German city. Lithographs for *Odyssee*.

1965
Journey to Morocco where he sketches for a lithograph series titled *Marrakesh*. Exhibition of his graphic work at the Museum für Kunst und Gewerbe in Hamburg.

1966
Exhibitions to commemorate Kokoschka's eightieth birthday: *Homage to Kokoschka* (Marlborough Fine Art, London); *Oskar Kokoschka – Watercolors and Drawings* (Staatsgalerie Stuttgart); Retrospective exhibition at the Kunsthaus in Zurich; *Oskar Kokoschka – The Portrait* (Kunstverein Karlsruhe); *Kokoschka* (Marlborough-Gerson Gallery, New York); Arts Council Exhibition travelling in England. Paints *Saul and David* (January), *Konrad Adenauer* (April), *The Rejected Lover* (May), *Berlin - 13 August 1966* (August) and *New York, Manhattan with the Empire State Building* (September/October).

1967
Travels to Libya and Tunisia. In April in London to paint a new Thames riverscape, a view from the Shell Centre towards the Houses of Parliament. Original drawings for the lithographic series *London from the River Thames*. Autumn in Villeneuve: Preliminary drawings for the cycle of etchings *The Frogs* after Aristophanes.

1968
Travels to Turkey and paints *Istanbul II*. Summer in Villeneuve. Painting *The Frogs* with an inscription on the back referring to the invasion of Prague by Russian tanks: "Europa's Sunset 1968 – Prague 23.8.68".

1969
London and Scotland. Marlborough Fine Art, London publishes the lithographic portfolio *Saul and David* and presents the new graphic series. *Paintings: Self Portrait 1969, Agatha Christie* and *The Duke and Duchess of Hamilton*.

1970
Begins writing his autobiography Mein Leben (My Life). From late June to the end of July in London to paint his last London view: *View of the City with St. Paul's Cathedral*. Elected an honorary member of the Royal Academy.

Publication of his ten etchings illustrating Heinrich von Kleist's tragedy *Penthesilea*.

1971
Visits the island of Djerba again and travels on to Rome. Major retrospectives to celebrate his 85th birthday at the Oberer Belvedere in Vienna and in the Haus der Kunst in Munich (*Oskar Kokoschka - Portraits from 1907 to 1970*). Publication of the German edition of his autobiography; English edition to follow in 1974. Begins to work on one of his most impressive late paintings, *Time, Gentlemen please*.

1972
Spring: Temporary illness. Begins to re-read his own writings, especially the drama *Comenius*, to prepare an edition of his written work (subsequently published by Heinz Spielmann in four volumes between 1973 and 1976). April and May in Greece; in October in Burgundy. *Peer Gynt*, one of his last oil paintings, is named after the hero of Henrik Ibsen's play.

1973
Travels to Israel and Sicily. Series of lithographic portraits *Jerusalem Faces*. In July opening of the Oskar Kokoschka Documentary Archive in the house where the artist was born in Pöchlarn. Portfolio *The Women of Troy* published in London.

1974
Visits Madeira in spring. In May an eye infection severely impairs his sight., Autumn: Supervises the filming of *Comenius* in Hamburg.
Exhibition at the Musée d'Art Moderne de la Ville de Paris.

1975
At the end of January cataract operation in Lausanne. The Austrian chancellor Bruno Kreisky succeeds in persuading Kokoschka to reassume Austrian nationality. Lithographic cycles *Comenius* and *Pan*, following Knut Hamsuní's novel. Oskar Kokoschka - Das druckgraphische Werk, compiled by Hans M. Wingler and Friedrich Welz, is published in Salzburg.

1976
Deeply shattered by the death of his younger brother, Bohuslav, on 12 January. Exhibitions to celebrate his 90th birthday in Salzburg, Munich, Linz, Vienna, London, Athens and Bregenz. Awarded an honorary doctorate by the Philosophical Faculty of the University of Salzburg.

1978
Major retrospective in Japan in Kamakura, near Tokyo, and Kyoto. Collaborates on preparations by Olda Kokoschka and Heinz Spielmann to publish his letters.

1980
Dies in hospital at Montreux on 22 February and is laid to rest in the cemetery at Clarens, above Montreux.

Oskar Kokoschka as a Graphic Artist

Throughout his long artistic career, prints formed an important part of Kokoschka's output. His first prints were made in his early 20's, when he created a series of color lithographs to illustrate a children's book.

In the early stages, his most significant images were powerful portraits and self-portraits. Later, in the Thirties and Forties, he made comparatively few prints. But his enthusiasm was rekindled in the Fifties, and he continued to make major portfolios until his death.

Although he worked in various media, his first love was lithography. This he treated like his drawings. He considered lithographs not as sketches for paintings but discrete works of art. They started as "written notes, which are stored in my memory. From there they grow and develop".

Where possible Kokoschka drew directly onto the lithographic stone, and there is an immediacy and vigor in his approach. At the same time, the images are intensely personal, and Kokoschka noted that each of his lithographs was a variant of his personal credo. Whether a portrait, a flower still life, a diary of his travels or an interpretation of a literary epic, each piece has a clear Kokoschka identity. It is a reflection of the artist—it is part of a self-portrait.

A fine selection of Kokoschka's graphic work is available from Marlborough Graphics in London & New York.

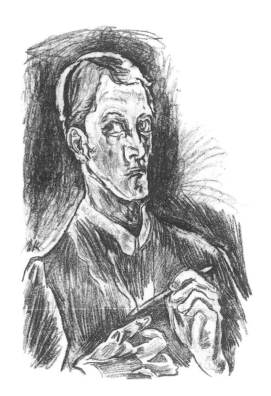

Selbstbildnis (Brustbild mit Zeichenstift) 1914
Lithograph, from the edition of 25
18 x 12.1 in / 45.5 x 30.5 cm
Reference: Wingler/Welz 58

Marlborough

New York

Marlborough Gallery, Inc.
40 West 57th Street
New York, NY 10019
Telephone 212.541.4900
Telefax 212.541.4948
www.marlboroughgallery.com
mny@marlboroughgallery.com

Marlborough Chelsea
211 West 19th Street
New York, NY 10011
Telephone 212.463.8634
Telefax 212.463.9658
IPAMarlborough@netzero.com

Florida

Marlborough Florida
Gallery Center
608 Banyan Trail
Boca Raton, FL 33431
Telephone 561.999.9932
Telefax 561.999.9610

Agents for:
Magdalena Abakanowicz
Avigdor Arikha
Fernando Botero
Claudio Bravo
Grisha Bruskin
Anthony Caro
Vincent Desiderio
Richard Estes
Red Grooms
Israel Hershberg
Ignacio Iturria
Marisol
Raymond Mason
Tom Otterness
Beverly Pepper
Arnaldo Pomodoro
Larry Rivers
Guillermo Roux
Tomás Sánchez
Hunt Slonem
Clive Smith
Kenneth Snelson
The Estate of Jacques Lipchitz
The Estate of James Rosati

London

Marlborough Fine Art (London) Ltd.
6 Albemarle Street
London W1S 4BY
Telephone 44.20.7629.5161
Telefax 44.20.7629.6338
www.marlboroughfineart.com
mfa@marlboroughfineart.com

Agents f...
Fran...
Chri...
Steve...
Lynn...
Cher...
Step...
Chris...
John...
Dani...
Karl...
Diet...
Mag...
John...
Bill J...
Ken...
R.B....
Chris...
Théré...
Celia...
Sarah...
Paula...
The ...
The ...
The ...

Madrid

Galería Marlborough, S.A.
Orfila, 5
28010 Madrid
Telephone 34.91.319.1414
Telefax 34.91.308.4345

Agents for:
Juan José Aquerreta

Marlborough Offices

Galería Marlborough
Acevedo 850
1414 Buenos Aires, Argentina
Telephone 54.01.777.0916
Telefax 54.01.777.0916

Marlborough Galerie AG
Spiegelhofstrasse 36
8032 Zürich, Switzerland
Telephone 41.1.268.80.10
Telefax 41.1.268.80.19

Marlborough Graphics
40 West 57th Street
New York, NY 10019
Telephone 212.541.4900
Telefax 212.541.4948
graphics@marlboroughgallery.com

Marlborough Graphics
6 Albemarle Street
London W1S 4BY
Telephone 44.20.7629.5161
Telefax 44.20.7495.0641
graphics@marlboroughfineart.com

Important Works available by:
Impressionists and
 Post-Impressionists
Twentieth-Century
 European Masters
German Expressionists
Post-War American Artists

Design: Scott Marshall
Research editor: Sheri Pasquarella
Production assistance: Kate Gilmartin
 Inna Khmel
 Paola Gribaudo
In London: Armin Bienger
 Christine Hoffmann

Page 13, photo ©Albright-Knox Art Gallery,
Buffalo, New York; page 15, photo ©The
Phillips Collection, Washington DC; page 19,
photo ©Grand Rapids Art Museum, Grand
Rapids, Michigan; page 21, photo courtesy
Galerie Beyeler, Basel, Switzerland

Printed in Italy
© 2001 Marlborough Gallery, Inc.
ISBN 0-89797-215-5